Jesus Christ, Movie Star

Edward N. McNulty

Read The Spirit Books

an imprint of
David Crumm Media, LLC
Canton, Michigan

For more information and further discussion, visit
www.ReadTheSpirit.com/Visual-Parables

Cover art and design by
Rick Nease
www.RickNeaseArt.com

Published By
Read The Spirit Books
an imprint of
David Crumm Media, LLC
42015 Ford Rd., Suite 234
Canton, Michigan, USA

For information about customized editions, bulk purchases
or permissions, contact David Crumm Media, LLC at info@
DavidCrummMedia.com

Dedicated to the youth and adults who have inspired me and borne patiently with me at workshops and seminars around the country and to the five youth closest to my heart, Nevi, Ellen, Rebecca, Paul, and Daniel.

Contents

Acknowledgments

*Therefore, since we are surrounded by so great a
cloud of witnesses, let us also lay aside every weight
and the sin that clings so closely, and let us run with
perseverance the race that is set before us, looking
to Jesus the pioneer and perfecter of our faith ...*

Hebrews 12:1-2a

No author really writes a book alone. Therefore, I fondly
acknowledge the inspiration of the following "great cloud of
witnesses" through the years:

Drs. Alfred and Dorothy Edyvean, who, during my high
school and college years, inspired me. The first as a teacher
at Christian Theological Seminary leading me to see theater,
television and faith as partners and the second, my Sunday
school teacher, gently nudging me into the ministry.

Dr. John Burkhart, whose courses at McCormick
Theological Seminary deepened my understanding of the
theological themes in literature, and thus, film.

G. William Jones, whom I've never met, but whose books,
Sunday Night at the Movies and *Dialogue With the World*, a
program created for Films Incorporated, nurtured my first
film discussion groups.

Stanford Summers, founder of the St. Clement's Film
Association, who introduced me to the wonders of NYC and
led me to explore world cinema.

Fred and Mary Brussatt, whose early film reviews (in
the late '60s) set a high standard for my own and whose
encouragement has meant much to me throughout the years.

Clifford and Jan York, of Mass Media Ministries, who kept me abreast of worthwhile short films and who later invited me to contribute to their newsletter.

Dennis Benson, a seminary classmate, mentor in media and longtime friend (our families shared lots of after-church picnics).

The Benedictine monks at Abbey Press, publisher of my first book, who dared to feature a Presbyterian minister as the media critic for their Marriage and Family Living Magazine for a decade.

Robin Kash, who for several years published my film journal Visual Parables and agreed to expand it from newsletter to magazine length.

Nicholas Adams, publisher of LectionAid who saved Visual Parables twice—first by taking on its publication after Kash Literary Enterprises had to withdraw, and then by turning it into a web journal when printing and distributing grew too expensive.

My editors at ReadTheSpirit, David Crumm, Paul Hile, and Dmitri Barvinok who have been co-laborers in the long process of preparing this book.

To the above, and many, many more, I am grateful.

Preface

Ever since I can remember, I have loved going to the movies. Today more often than not I watch them via an app on my tablet. I still occasionally go to a theater—though these days that's usually with my granddaughter to catch the latest animated blockbuster.

Ed McNulty has been a major part of my enjoyment of movies over the years, thanks to his incredibly helpful reviews of a multitude of these *Visual Parables*. Now, he has produced a book that can be immensely helpful to church groups looking for a fun and faith-building study guide focusing on movies about Jesus.

As a person of faith, I have always enjoyed watching films that not only try to capture the grandeur and meaning of the stories of the Bible, but also those that say something about faith, or God, or how we live as human beings on this little planet in a more allegorical fashion. I've come to realize that sometimes you can discover very powerful truths in the most unexpected places—including films. Ed is way ahead of me on that realization.

The very first movies I saw in a theater were biblical blockbusters and, frankly, for better or worse they helped to shape my mind's images of many of the Bible's characters and events. I am a Preacher's Kid (PK), and my Methodist pastor father and mother would occasionally take all of us kids to see such films.

One of the first I recall watching raptly (though it sure was long!) was a re-release of Cecil B. DeMille's "Ten

Commandments" with Charlton Heston, from which I learned all about the Exodus. I also discovered one of my favorite Bible verses, the one where Nefretiri says, "Oh Moses, Moses, you stubborn, splendid, adorable fool!" (Isn't that in the book of Exodus somewhere?)

What helped form my earliest conception of Jesus was the film, "The Greatest Story Ever Told," wherein Jesus is portrayed by a blue-eyed Swede, Max Von Sydow. And blue-eyed Jeff Hunter only compounded that image in "King of Kings." As Ed points out in this book, Jesus very likely looked nothing like either of those great actors. I've spent years trying to learn more about the Jesus of the Gospels in a more accurate fashion.

Nevertheless, I learned a lot about the story of Jesus through these and other films, and with Ed's guidance, you and your friends can too. These movies can open up wonderful contemplations and conversations about our faith—and who it is that we are trying to follow. Whether these films retell biblical stories directly or present Christ figures through their narratives, they can be powerful tools for spiritual growth. And Ed knows that well.

This book is certain to provide countless church groups, including yours I hope, with helpful guidance and insight into a wide range of wonderful films. You'll find your enjoyment and appreciation of these diverse movies expanding exponentially as you share with others what you learn from them about faith and life.

And who knows, you may even grow closer to the living, loving, creative God, who so often surprises us in the most unexpected places.

—**The Rev. Peter M. Wallace** is Producer and Host of the "Day1" radio program. He is an Episcopal priest based in Atlanta and is the author of many inspirational books, including *The Passionate Jesus: What We Can Learn from Jesus about Love, Fear, Grief, Joy and Living Authentically.*

Foreword

There he was, a Swedish Jesus in a Kenyan marketplace. Standing out in all his conflicting nature projected onto a bed sheet hung between a tree and a lamppost in the dark, bustling night-market in Emali, Kenya—a truck-stop town located along the Mombasa-Nairobi highway known for its non-stop nightlife and borderland personality. As I was watching "The Jesus Film" in Emali I could not help but wonder what this *very* white Jesus was communicating in a town center where I was the only other Caucasian.

Was there a disconnect or did the film still communicate? Although the language dubbed over was Kiswahili, did the image of Jesus translate? If so, what did it communicate? What were the 200 people in this crowd thinking about the Christian faith? What did they make of this film?

Images of Jesus are important. Especially moving images in films such as *The Jesus Film, The Passion of the Christ,* or *Jesus Christ Superstar.* Moviemakers know this. As Edward McNulty—the pastor of *Visual Parables*—writes: "One thing investors have understood since the dawn of moving pictures is that portrayals of Jesus matter deeply to American viewers. It's not surprising that Jesus on the big screen tends to look a lot like the majority of European-American filmgoers. That's been a Hollywood truth for more than 100 years."

Images of Jesus not only matter to American moviemakers, and goers, but to people throughout the world. In a global

culture, the internationalization of these images occurs across, through, and in tension with various sites and conduits of ethnicity, technology, financial systems, media, ideological networks, and religions. Hence the importance to critically think through what depictions of Jesus mean — how they are represented, how they communicate, how they are interpreted, and how they reflect, critique, and interact with wider socio-cultural realities.

The Good News Is ...

This book is meant to spur Christian and non-Christian alike to do just that—to think about the ways that Jesus stars in various films about his life, of his life transfigured into different times and cultures, or when a character takes on essential Christ-like qualities and actions in a way that is central to the movie's plot. This discussion invites readers to rethink faith and film in blunt and powerful ways.

The good news is—people want to talk about this stuff. McNulty's work at Visual Parables is well-received, widely read—and discussed. Indeed, it's that final aspect that is the greatest strength in McNulty's work. Not only does he lead us into in-depth considerations of faith and film, but he provokes people to engage in rich conversations of faith and film.

Why Are Spiritual Movies So Popular Now?

There is no better historical moment than the present to be having these exchanges. Biblical movies and Christian films are big money right now. Toss in Bollywood's Hindu epics, Muslim comedies and documentaries distributed on Netflix—plus other films with religious/spiritual themes—and the category "spiritual movies/TV shows" makes up a significant slice of the film and television industry.

But why?

In my estimation, there are three reasons for the proliferation of biblical blockbusters and spiritually themed television and media: 1) the persistence of religion and the re-enchantment of the cosmos in a global age; 2) the important role of media in belief in such an age; 3) the piety of visual culture and media.

1) Persistence of religion, re-enchantment of the world.

It seems, by now, that the dim prophecies of the secularization theorists—that with the advent of modernity religion would fade into the background or go completely extinct in the face of a rising tide of secularization—were overblown at best. While secularization, at the public and private level, is worth studying and is still a potent force at work in the world there has by no means been a drop off, or even a marked decline, in religion around the world.

Indeed, we have seen the complete opposite. In the face of late modernity and its global and fast-paced dimensions, our world has been re-enchanted with divine intimations and spiritual promptings. As individuals and communities are (re) introduced to a whole buffet of religious and spiritual options to help them make sense of themselves, those around them, and indeed the entire cosmos—they are finding that religious options for explanation often outweigh secular ones.

That doesn't mean secular values are never present, but they are increasingly consumed, co-opted, and now are existing side-by-side with spiritual affirmations, worldviews, and lifeways. For examples, a staunch affirmation of the theory of evolution can go hand-in-hand with the Gaia principle and a thoroughly modernistic approach can typify the structural approach of a seemingly pre-modern religious terror organization.

The modern and secular are viewed through the lens of the late-modern religious impulse at work within many of us. Those religious systems and spiritualities that are doing best are able to bridge the chasms wrought by modernism. They

are able to weave together the global and the local, the transcendent and the imminent, the spiritual and the physical, the personal and the cosmic, the individual and the communal, the imagined and the material. These successful religions are furthermore personal, portable, and practical.

This is where the religious use of the media, and the media's use of religion, comes to the fore.

2) *The important role of media in belief in such an age*

Dr. Stewart Hoover, Director of the University of Colorado's Center for Media, Religion, and Culture, has said that "the media determine the transnational civil sphere in important ways." Not only does media bear witness to religious and spiritual trends, reporting, recording, and re-imagining them in audio/visual dimensions, but the media also are a source of religion and spirituality, compete for devotees and practitioners, and are indicators of religious and spiritual change.

So what is the proliferation of religious media indicating to us about the trends in the re-enchantment of the world? Anthropologist Harvey Whitehouse has written about what he calls the shift from "doctrinal religions" to "imagistic" ones. The doctrinal mode of religion is characterized by a top-down hierarchy, involving regularly repeated daily or weekly rituals, written texts, standard teachings and lower levels of emotional arousal. Imagistic religion is less structured, with little or no hierarchy or doctrine, characterized by periodic festivals with high levels of emotion that mark a break from regular daily life. Imagistic religions utilize ecstatic trance states and altered forms of consciousness to bring about direct divine contact; doctrinal religion employs mediators to interpret the divine. Imagistic can also be imagined in its literary sense in which it refers to a poetic movement in England and the U.S. during, and around, World War I, that emphasized the use of ordinary, vernacular speech and the precise presentation of images to arouse reaction.

As religious adherents are looking to personalize, localize, pragmatize, and spiritualize their religious practice (over and

against corporate, global, sentimental, and institutional forms of belief and practice) they increasingly look to media in order to do so. Hoover, again, said:

> *Media provide rich symbolism, visual culture, salient contexts and practices of social participation and identity, and opportunities to make and remake identities and social relationships to fit evolving patterns of ideas and action. The media are, further, the dominant and definitive source of what is socially and culturally important in modernity. Journalism acts in this way by setting the agenda of public and private social discourse. The entertainment and advertising media do so by creating and maintaining taste cultures through which identities are given value.*

Media then become our new "doubting Thomas" encounters. Whereas Thomas was bidden to touch Jesus' side and feel his wounds religion in the media age invites us to see Jesus' side pierced via "cathode ray tubes" (to use Kurt Vonnegut's anachronism for television) and to watch his wounds on the big screen.

3) *The piety of visual culture and media*

In this age when the world is desiring the spiritual, but not the religious, media becomes a near-perfect conduit for such religious pursuits. It's no wonder that we desire "visual piety."

But what is its effect?

In his book *Visual Piety: The History and Theory of Popular Religious Images*, Dr. David Morgan illustrates that popular visual images—including television images, velvet paintings, prayer cards, talismans, or movies—have assumed central roles in contemporary U.S. spiritual lives and religious communities.

Not only does Morgan situate American Christianity's practice of visual piety in the *longue-durée* of history showing that it is not necessarily *new*—that it does not represent the rupture we think it does when history is taken into effect

(think of icons, stained glass windows, sacred paintings, etc.)—but he also contends that religious aesthetics must be viewed in the context of social reality. That is to say, we have to understand what is happening with us in order to understand what is happening with the proliferation of religious movies and TV shows, etc.

Morgan wrote, "The point behind the visual culture of popular piety is not principally an admiration of skill, which pertains to the manipulation of a medium, but admiration for the object of representation…We can therefore speak of beauty in visual piety as consisting…in the reassuring harmony of the believer's disposition toward the sacred with its visualization."

I quote Morgan at length here to silence all the critics who complain about Kirk Cameron's crappy acting in, well, pretty much any Christianese films he makes these days. It's also to contend with those who want to critique the TV series *A.D.* based on its visuals or its score or all those British accents. Morgan is making the point that these evaluations are not all that important.

What really makes visual piety in the form of biblical movies and Christian television beautiful is its representation of the divine object itself—in this case the beholding of the Trinitarian God of Christianity (but we could also extend this and apply it to Bollywood's representations of Hindu epics, for example).

Media, specifically in this case television and movies, embody and represent the very rise of modernity that many scholars once thought would be the harbinger of rapid social change and secularization. Instead, what we find is that all forms of media—from comic books to computer screens, from smart phones to cinemas—have been imbued with sacred images and representations. This means that instead of chasing religion out, media has presented a new conduit for visual piety. Media has become a new way to admire "the object of our [religious] admiration" and over and against the dangers

of secularization, late modernity, and pluralism—viewers can attest to the reality, the portability, and the visual-tangibility of "our God" via the screen. That's true whether we be Christian or Jewish, Hindu or Neo-Pagan.

The Re-sacralization Of The World Via Media

To sum up, the three categories of films that McNulty works with here should not be solely evaluated based on award-winning effects, writing, production, acting, or lack thereof. Instead, they should be appraised as a benchmark of the re-sacralization of the world in a new media age.

As media and modernization threaten to strip us of our religious imagination these new forms of visual piety are important mediums for confirming, or challenging, our religious curiosities and convictions and bearing us forward as religious beings in a global age. In effect, they are the cathedrals and temples of our age, where we go to encounter the divine.

With that, expect more biblical movies, Christian-themed television shows, and spiritual media to come. Just as the faithful have given of their time, talents, and treasures over the years to build edifices to their religious sentiments and to bear testament to the divine in brick and mortar, stone and stained-glass, so too we will shell out our hard earned cash to see a movie that reassures us of our beliefs in visually appealing forms such as TV shows and movies.

Furthermore, expect that this book will prove useful both in the midst of this massive biblical-movie moment and for years to come as we continue to consume cultural products that demand serious discussions of their themes of faith or their depictions of Jesus—whether literally or metaphorically.

In this midst of the conversations that McNulty is inviting us into, we might be surprised with what we find. I certainly

was impressed by the reaction to "The Jesus Film" I observed in Emali. As the story progressed, the ethnically and culturally juxtaposed Jesus on the screen nonetheless enraptured the gathered crowd. With audible gasps, laughter, and groans the viewers were wrapped up in the narrative, not in its aesthetics. They were drawn in by Jesus' story, not his representations. While, perhaps, there is still room to critique culturally ignorant representations of religious and cultural figures in film, there is much more to discuss in terms of how people are receiving, and reacting to, the film's story itself.

McNulty's subsequent exploration of Jesus-figures, faith, and film gets us started down a path to not only catch the great importance of Jesus' story as it was, but also — crucially — how it is transported and transposed in our current culture. To that end, enjoy this wonderful work from McNulty and engage heartily in discussion with those with whom you watch, react to, and examine faith and film.

—**Ken Chitwood** is a religion scholar with interests ranging from Islam in the Americas to the intersection of religion & popular culture and writes & speaks on this topic as both an academic and a journalist covering 'the god beat.' He is also a forward-thinking and global Lutheran theologian keen to cross religious boundaries, physical borders, & cultural barriers in service of the local church & community.

Jesus as a Movie Star?

Imagining Jesus

What did Jesus look like?

Silly question, you might say. Of course we know what Jesus looked like! We have grown up with countless images of Jesus showing long brown hair, a beard, a robe and sandals. But did any of these artists ever see the historical Jesus? What is the basis of their images? Do you know of any physical description of Jesus in the New Testament? For example, what was his skin *really* like—ruddy and light textured like most of his American portraits show, or darker, more olive-hued, like residents of the region in which he lived? Was he tall and thin, or of medium height and muscular? Was he good- looking? One of the early church fathers maintained that he was scarred and ugly, echoing a passage from Isaiah 53: *"He had no form*

or comeliness that we should look at him, and no beauty that we should desire him."

All of us have been influenced by depictions of Christ in paintings, movies, advertisements and artwork in churches. In some regions of the U.S., Jesus peers out at us from billboards, murals and even giant statues along the highway.

But there were no cameras in Jesus' time. In the ancient world, wealthy Romans enjoyed commissioning portraits of themselves and their heroes. However, portraiture was not a part of Jesus' Jewish community, which condemned such images as dangerously idolatrous. Jesus never posed for a portrait—nor did any artist, as far as we know, capture his image during his lifetime.

This might be just as well. The lack of a contemporary image of Jesus has allowed artists through the centuries to come up with their own version of how Christ might have looked. And what a variety of portraits they have provided! In catacomb paintings and mosaics from the early centuries of Christianity, we see Jesus as a Roman-style, toga-clad, beardless youth. In Orthodox churches around the world, we look up into soaring domes to find a majestic bearded Jesus staring down at us as a triumphant ruler. Travel across Asia or the Southern Hemisphere and we find a darker-skinned Jesus in many forms that may surprise American Christians.

It is no surprise then that filmmakers from Hollywood and Europe have portrayed Jesus in many forms and settings. However, virtually all portray him as Caucasian—even with blue eyes in a couple of movies. While they have formed a cinematic concensus on his physical appearance, other artists are continually attempting to open our eyes.

At the turn of the millennium, the National Catholic Reporter (NCR) challenged artists to develop new images of Jesus. The judge was Sister Wendy Beckett, a British nun and art historian who appeared in popular PBS programs produced to introduce TV viewers to the fine arts. The winning image in the NCR competition was painted by artist

Janet McKenzie and was called "Jesus of the People." That new image of Jesus made headlines for McKenzie's choice of modeling this new Jesus on an African-American woman. Sister Wendy said, "This is a haunting image of a peasant Jesus—dark, thick-lipped, looking out on us with ineffable dignity, with sadness but with confidence. Over His white robe He draws the darkness of our lack of love, holding it to Himself, prepared to transform all sorrows if we will let Him."

Sucessful filmmakers don't have as much visual courage as McKenzie. Hollywood productions risk millions of investors' dollars in making and promoting a feature film. One thing investors have understood since the dawn of moving pictures is that portrayals of Jesus matter deeply to American viewers. It's not surprising that Jesus on the big screen tends to look a lot like the majority of European-American filmgoers. That's been a Hollywood truth for more than 100 years.

Nevertheless, filmmakers have explored many dimensions of Jesus' life and his relevance for us today. Sometimes, they tell us stories with Christ-like themes about unusual men and women facing dramatic challenges—stories that make us think of Jesus and our Christian faith in provocative, new ways. In this book, you will find study guides for three different kinds of films about Jesus. Inspired by Theodore Ziolkowski's book *Fictional Transfigurations of Jesus*, I call these three approaches: Life of Jesus, Jesus Transfigured and Christ Figure.

Life of Jesus

Hundreds of movies, from feature films to shorts, include scenes from the life of Jesus of Nazareth. In producing these movies, filmmakers decide whether to stay strictly within the limits of what they find in the New Testament, or they may bring in non-biblical characters or incidents to add more drama or to explain the customs and setting of the story for the audience. Of the films discussed in this book, only the creators of *The Gospel According to Matthew* and *The Gospel of*

John tried to limit their screenplays to the Gospel text, whereas the others include extra material for artistic or theological reasons.

Jesus Transfigured

In a Jesus Transfigured approach, filmmakers transfer the plot to a different time and culture, often as if answering the question: "What would happen were Christ to come to our city today?" Many, though not all, of the elements or incidents of the Gospels are included, such as the scenes in which Jesus faces temptations, Jesus moves around calling his followers, some amount of Jesus' teaching, betrayal, crucifixion and sometimes a type of resurrection. The filmmaker's purpose is not to retell "the life of Jesus," but to comment on today's world by showing what might happen if a Christ-like figure could enter someone's life today.

Christ Figure

In a Christ Figure film, a character is often betrayed and killed, or suffers a metaphorical death in the form of a defeat. The plot does not necessarily follow the Gospel story, but the main character, either man or woman, has reached out to those in need, triggering opposition by those profiting from the status quo.

This type of film takes us furthest from a Gospel narrative about Jesus. Sometimes, viewers may not even think of the movie as relating to themes about Jesus or the meaning of Christ today—unless a friend or discussion leader poses a question about these connections. These discussions may be more challenging for participants, but they also are full of surprises and may produce some of the liveliest conversations. How challenging are these connections to identify? Stop for a moment and consider whether you can think of connections with Christ in these films:

Broadway Danny Rose
Cool Hand Luke
Dancer in the Dark
The Day the Earth Stood Still
Dead Man Walking
E.T.
The *Harry Potter* series
The Green Mile
The Lion King
Lord of the Flies
Lord of the Rings series
The Matrix series
The Narnia series
One Flew Over the Cuckoo's Nest
The Spitfire Grill
To Kill a Mockingbird

In thinking about this list, you may have discovered the first discussion you can have with friends or your class or small group. Asking friends about a list like this will get them talking about their love of movies. Everyone is likely to have something to contribute. Unlike many religious discussions in small groups, people feel less of a burden about coming up with a "right" or a "wrong" answer when they are talking about movies. If an initial conversation is exciting, friends will be eager to dig deeper and undertake a longer series of movie viewings and discussions. This is fun, enlightening and inspiring.

Who Do You Say That I Am?

Talking about Movies Helps Churches Grow Spiritually

On any day, the list of hot topics on Google News and social media networks includes movies. Whenever you gather to relax and chat with friends and coworkers, Hollywood is likely to pop up in conversation. As you consider organizing a small group, you may wonder: Will this work?

I can assure you: It will. My online columns about movies always draw readers from across the religious spectrum including thousands of readers who come from websites that serve clergy and lay leaders. There is widespread interest in faith and film. Are you eager to start a discussion series, but a bit anxious about the idea? I can assure you: This will work.

For decades now, I have led film discussion groups in the United States and Canada. My earlier books about faith and

film are used in congregations nationwide. In 1990, I founded a newsletter that grew into a monthly faith-and-film journal, *Visual Parables*, which helps people use movies in congregations. That journal, including many free movie reviews I publish each month, is now online at www.VisualParables. org. I urge you to visit that website and sign up for free email updates when new reviews and monthly issues of the journal are published.

I'm not only a writer and facilitator for discussion groups; I'm also a pastor, now retired from parish ministry. Some years ago, I combined all of my professional roles and hosted a film series in a downtown theater in Dayton, Ohio during Lent. We often invited special guests to get these discussions started. When we showed *The Saint of Fort Washington,* starring Danny Glover and Matt Dillon as two men living on the streets, we invited the director of a local homeless shelter to co-lead a discussion after the screening. When *Philadelphia* was our featured film, we invited an activist who brought along a mother with HIV/AIDS to share her story—and what a moving testimony we heard that night!

Now, I write and teach other facilitators how to carry these ideas to their congregations. One venue that I trained group leaders in for a number of years was the Presbyterian Peacemaking Conferences. Here, I convened workshops on films related to conference themes. Each workshop participant carried home not only fresh training in starting film discussion groups, but also a long list of movies to spark discussions in their communities. This book has everything you need to easily get a movie series going, right down to specific details about finding the most thought-provoking scene on the DVDs and in reading the most relevant passages from the Bible.

These connections between faith and film are largely missing in other media covering Hollywood, so we all need help finding overlooked movies and raising questions that can help us see and hear their deeper truths. Pop some popcorn and invite your friends. This is fun and spiritually enlightening.

From many years of guiding viewers, I know what details you will need to host a successful evening. If you are not part of a group right now, you still can enjoy this book for your own viewing. Most of the films included in this book are easily available from the media services now reaching American homes including Netflix and Amazon.

By exploring movies in this way, we are following Jesus' example of using stories to enlarge his followers' vision and challenge them to live as if his kingdom of love and justice had already come. That's why I have called my monthly journal and website *Visual Parables*.

Because nearly everyone enjoys talking about movies, this kind of program is a terrific way to welcome newcomers and energize inactive members in growing congregations. If you find yourself trying to convince clergy and lay leaders that this is a good idea, tell them that a faith-and-film series is likely to bring new faces into the congregation and, depending on how you choose to organize your series, could lead to church growth.

You Could Start with These Questions

This book is designed to be flexible. You can use some or all of the detailed study guides that form a major portion of this book or you can jump to the end of the book for ideas about discussing other films related to Jesus that you might prefer to add to your series. You can start anywhere: The previous chapter poses one set of questions (asking friends to discuss possible connections between Jesus and a list of more than a dozen very popular movies). Or, you may want to start with some generic questions.

Here are some tested ideas for starting discussions if your friends, or your small group, has watched a Jesus-themed

movie. Based on my many years of experience in leading such groups, you might consider these eight questions:

1. **What does Jesus look like?** This simple question is guaranteed to touch off a lively conversation. How is Jesus portrayed in the movie? How does that compare with your own impressions of Jesus? What's the most dominant image of Jesus for each participant? You might even invite participants to draw pictures or to bring their own favorite pictures to class. Check your church school's picture file for examples of portraits.

2. **How does the filmmaker show Jesus' humanity and divinity?** Most films that touch on Jesus try to explore one or both aspects of Christ's nature, which is one of the great mysteries at the heart of the Christian faith. If you discuss this kind of question as it is portrayed in the movie, group participants also have an opportunity to share and discuss their own beliefs about Jesus. You'll likely find a diversity of viewpoints surfacing about this issue, so you might want to prepare for this discussion by talking with clergy or bringing in creeds or statements of faith used in Christian tradition.

3. **Is the script faithful to the Gospels?** This question opens up many avenues for discussion and learning. Remember that Gallup polling repeatedly shows that Americans widely claim to own and to have read the Bible. However, each time this polling is conducted, less than half of Americans can name the four Gospels. That means people collectively love the Bible, but they have a limited knowledge of biblical texts. Especially if you draw newcomers to your congregation for a faith-and-film series, keep in mind that many of your participants won't know the

Gospel stories by heart. This is a great opportunity to get participants digging into the Gospels to see how the Bible compares with what's on the big screen. If you discover striking differences from the biblical accounts, then ask: Why do you think the filmmaker made those changes? Which version of the story is most meaningful to you today?

4. **What do you think about the miracles?** Some movies show scenes involving Jesus' miracles; some don't. Discussing miracles is a spirited conversation! Once again, expect some participants to have little knowledge of the biblical accounts when you start such a discussion—build into your group an opportunity to return to the Gospel texts. In each chapter of this book, I provide appropriate short readings for each of the 12 films I recommend.

5. **Does the Jesus on the big screen seem to pose a threat to society to warrant deadly opposition?** What is the challenging message of this particular Jesus in this particular movie? How does it compare with the Gospels? Is this cinematic Jesus emphasizing one or two points in this screenplay, but forgetting other powerful messages recorded in the Bible? How have the filmmakers portrayed the controversial side of Jesus and his ministry?

6. **How is the theme of resurrection handled in this movie?** What do the Gospels say? How do group participants envision this mysterious and challenging part of Christianity? Does the movie's portrayal of resurrection inspire viewers or arouse disagreement?

7. **Organize an interfaith discussion.** Many communities across the U.S. have active interfaith organizations through which your congregation could bring together Jewish and Christian

participants to discuss the portrayal of Jesus in a movie. Very sensitive issues are raised in such discussions, including misunderstandings about the role of Jesus and the Pharisees within the first-century Jewish community. Since the 1960s, the Vatican and most major Protestant denominations have encouraged such interfaith conversations as a healthy way to combat bigotry and encourage an appreciation for our religious diversity. You will be most successful if you get local clergy and lay leaders involved in thoughtfully organizing such a discussion.

8. **Discuss scenes in the movie you are watching compared with popular depictions of those scenes.** This is a powerful way to zero in on specific scenes within a film, drawing on participants' already existing memories of such scenes. Most of us carry around a whole host of visual images from paintings, TV shows, movies and illustrations in Bibles and devotional literature. These days, famous images of Jesus are widely available online. Check to ensure that you are properly observing copyrights, but thousands of sacred images are available in rights-free databases like Wikimedia Commons. There are many ways to search for intriguing images of Jesus. Consider bringing in a large-format book that collects the work by a single artist, such as Rembrandt, whose paintings of Jesus have drawn huge crowds to museum exhibitions in recent years. Here are some titles and phrases to search online that will identify many famous images that you could share with your group:

The Annunciation
Journey to Bethlehem
The Nativity
Angels and Shepherds
Visit of the Magi
Baptism of Jesus
Jesus Tempted in the Wilderness
Jesus in the Temple
Jesus Calling the Disciples
Jesus Teaching the Crowd
Jesus Healing the Sick
Mount of Olives
Mount of Transfiguration
Jesus' Entrance into Jerusalem
Jesus' Controversies with Enemies
Jesus' Prediction of the Temple's Destruction
Jesus Washes the Disciples Feet
The Last Supper
Jesus Predicts His Betrayal
Garden of Gethsemane
Jesus' Trial Before the Sanhedrin
Jesus' Trial Before Pilate
Crucifixion
Pieta
Jesus' Tomb
Jesus' Resurrection and Appearances to Disciples
The Ascension

Using the 12 Discussion Guides

Each of the 12 discussion guides in this book follow this format:

Title of the Movie

What year the movie debuted.

MPAA rating

There are dozens of content-rating systems used around the world. We follow the main system used in the United States, the rating codes assigned by the Motion Picture Association of America.

Ed's Content Ratings

Over many years, my non-scientific set of content ratings from 0 to 10 has become a popular highlight of my movie reviews and study guides. "Violence" refers to the level of violence you will find. "Language" refers to what American moviegoers commonly think of as "bad" or "rough" or "coarse" language. "Sex/Nudity" refers to the amount of such content in the film.

Running Time

The standard running time of the film. Occasionally, movies are available in more than one length.

Director

The film's director, which often suggests why particular themes or visual choices are made in a motion picture—although

other creative professionals may affect everything from the appearance of characters and settings to the final sounds and words heard in the movie. You may want to consult Wikipedia or IMDb to learn more about the entire crew involved in this production.

Cast

Role, then the actor's name. More cast members may be listed in the Wikipedia or IMDb entries for these films.

Scriptures

Recommended and relevant readings from the Bible that will help you spark discussion.

Key Scenes

Recommended film clip(s) to show in your discussion group. I have added notations about the way to find these scenes on a standard DVD copy of each movie. Remember that movies are often re-released in new formats, so the times and scene numbers may be different on your copy of the movie.

The Film

I describe the film—and you will find some "spoilers" in this portion of each chapter—so you can start your journey through these movies with a full understanding of each feature film I am recommending.

For Reflection/Discussion

This book is designed to be flexible. Use any of these questions in any order that makes sense to you. Or, add your own questions. The first two chapters in the book contain additional questions you might want to consider. Many readers enjoy going through my faith-and-film books alone, or with a spouse or good friend, so these questions may serve to prompt your own personal reflection. If you are going through this book alone, you might want to start a film journal to jot down your responses.

PART 1

Life of Jesus Films

CHAPTER 1

The Gospel According to Saint Matthew (1964)

(Available in both Italian language subtitled or an English dubbed versions.)

MPAA rating

Not rated

Ed's Content Ratings (0-10)

Violence **3**

Language **0**

Sex/Nudity **1**

Running time

2 hours, 17 minutes

Director

Pier Paolo Pasolini

Cast

Christ: Enrique Irazoqui
Young Mary: Margherita Caruso
Joseph: Marcello Morante
Herod I: Amerigo Bevilacqua
John the Baptist: Mario Socrate
Peter: Settimio Di Porto
Andrew: Alfonso Gatto
James: Luigi Barbini
John: Giacomo Morante
Herod II: Francesco Leonetti
Herodiade: Franca Cupane
Pontius Pilate: Alessandro Clerici
Older Mary: Susanna Pasolini

Scriptures

The Gospel of St. Matthew, plus:

He was oppressed, and he was afflicted,
yet he did not open his mouth;
like a lamb that is led to the slaughter,
and like a sheep that before its shearers is silent,
so he did not open his mouth.
By a perversion of justice he was taken away.
Who could have imagined his future?
For he was cut off from the land of the living,
stricken for the transgression of my people.
They made his grave with the wicked
and his tomb with the rich,
although he had done no violence,
and there was no deceit in his mouth.

—In context of Isaiah 52:13 to 53:12

Key Scene: Palm Sunday

Note: On my DVD the scenes are not numbered in the menu. This is the fifth scene, beginning at 1:18:58. Stop at 1:24:19.

Jesus instructs his disciples to get a donkey, which he rides into Jerusalem. People wave palm branches and spread garments on the ground. There are many children. Jesus' face, while not smiling, shows that he is pleased with his reception. The people are calling out "The Son of David" and "Hosanna." When he enters the temple courtyard, his expression changes to one of disapproval as he sees all the commercial transactions taking place. He angrily sweeps off the money and merchandise, quoting from Jeremiah the prophet. From windows opening onto the courtyard, we see priests looking down. As a crowd of the poor and the ailing come through the door toward him, Jesus breaks into a smile. A large group of children waving their branches and praising him leaves him beaming.

The Film

That a Marxist should make a literal film translation of Matthew's Gospel might be as difficult to accept today as it was back in the 1960s when word got out that Pier Paolo Pasolini, the infamous Italian Communist, was making a film about Jesus. That his film should come to be regarded as one of the finest film depictions of the story of Christ (LIFE magazine's critic called it the greatest religious film made, and the Vatican added it to their list of important films) is even harder to understand.

Working on a shoestring budget, Pier Paolo Pasolini used just a handful of professional actors.

Most of the disciples and other characters were portrayed by peasants and villagers from the rocky Italian countryside where the film was shot. The director even pressed his own mother into service to play the elderly mother of Christ at the cross. The choice to shoot the film in black and white was probably due to artistic as well as financial considerations, the stark contrasts giving the film a documentary look. This also avoids the "pretty" look of the big budget Hollywood epics, which are indebted more to Renaissance paintings of Christ and the countryside than to historic reality.

Note how few words are spoken between Joseph and Mary at the beginning of the film. The script sticks close to the order of the events in Matthew, with the sparse dialogue also adhering closely to that of the Gospel. Jesus is depicted as a lean, ascetic-looking young man always in a hurry, like a Marxist revolutionary who cannot wait to bring on the revolution—only in his case it is the kingdom of heaven. We see a good deal of the back of Jesus with the disciples hurrying to keep up as he teaches them on the run.

Some critics have remarked that Jesus was too serious in this film, never smiling. They are right about his being serious—indeed a revolutionary—but they forgot that there are shots of him smiling, always when he is with children.

Without all of the blood and gore of Mel Gibson's color movie, Pasolini conveys the horror of the crucifixion. Mary at the cross is not the prettied-up Mary of other Life of Jesus films (most notably the recent *Son of God*), but very much a peasant woman aged by her hard work in primitive circumstances.

There are no special effects employed, neither at the tomb on Easter Sunday nor when Jesus performs a miracle. Compared to Hollywood standards, this is a bare bones, shoestring-budget film. Yet to many film lovers, it is the best of the Life of Jesus films.

For Reflection/Discussion

1. How does this film compare with other images or films in which you've seen Jesus? Look at some other images from films or paintings from online sources.

2. Were you disappointed that this film was shot in black and white? How did you respond to this choice by Pasolini?

3. Were there things in this movie that you don't find mentioned in the Bible?

4. Discuss some of the individual sequences: What do you think of the way the Temptation in the Wilderness was depicted? The miracles of Jesus? Jesus' style of teaching on the run?

5. Why does opposition to Jesus arise?

6. Read Jesus' words in Matthew 10:34. Note their context: Have they been borne out in history? How have Christians been "troublemakers" and "outside agitators" through the centuries? For example, Martin Luther King, Jr. and other civil rights workers were always blamed for the violence perpetrated against them.

7. Why would the incident in Matthew 12:46-50 also be shocking? What is the implication for the church here? See Psalm 41:9 for a possible Scripture that Jesus might be referencing.

8. How is the death of John the Baptist important to Jesus' story? Look at other images of Salome's dance and John's execution in paintings or perhaps use a

video clip from another film you have encountered. Which ones play to the audience's interest in sex and spectacle?

9. When Peter makes his confession, Jesus announces his death and declares that the disciples must take up their cross (Matthew 16). What does Jesus mean by taking up your cross? Where do you see your cross in your life's journey?

10. What does the Gethsemane scene reveal about Jesus? Only Matthew 26:50 has Jesus addressing his betrayer as "friend." Is Jesus being sarcastic or naive here, or could he still be reaching out to Judas, even at this late moment?

11. What do you think of Pasolini's staging of the crucifixion scene? How does he show the anguish and pain? How about the resurrection scene? How is this a difficult event for the artist and filmmaker to depict, as compared to the crucifixion? Compare Pasolini's depiction of the Resurrection with the jazzed-up version in the TV miniseries *A.D. The Bible Continues*, with its ninja-like angel atop Jesus' tomb.

12. How would you describe Pasolini's Jesus, overall? Some have regarded him as an unsmiling revolutionary. What do you think?

CHAPTER 2

Jesus (1999)

TV Movie

MPAA rating

Not rated

Ed's Content ratings (0-10)

Violence **5**

Language **0**

Sex/Nudity **3**

Running time

4 hours

Director

Roger Young

Major Characters/Cast

Jesus Christ: Jermey Sisto

Mary, the mother of Jesus: Jacqueline Bisset

Joseph: Armin Mueller-Stahl

John the Baptist: David O'Hara

Satan (man): Jeroen Krabbé

Satan (woman): Manuela Ruggeri

Peter: Luca Zingaretti

Mary of Bethany: Stefania Rocca

Martha: Maria Cristina Heller
Mary Magdalene: Debra Messing
Caiaphas: Christian Kohlund
Herod Antipas: Luca Barbareschi
Salome: Gabriella Pession
Pontius Pilate: Gary Oldman
Livio, a Roman citizen: G.W. Bailey
Barabbas: Claudio Amendola

Scriptures

You may wish to draw on several Gospels for your discussion, plus:

He shall judge between the nations, and shall arbitrate for many peoples; they shall beat their swords into plowshares, and their spears into pruning hooks; nation shall not lift up sword against nation, neither shall they learn war any more.

—Isaiah 2:4

You have heard that it was said, 'An eye for an eye and a tooth for a tooth.' But I say to you, Do not resist an evildoer. But if anyone strikes you on the right cheek, turn the other also; and if anyone wants to sue you and take your coat, give your cloak as well; and if anyone forces you to go one mile, go also the second mile. Give to everyone who begs from you, and do not refuse anyone who wants to borrow from you.

—Matthew 5:38-42

Do nothing from selfish ambition or conceit, but in humility regard others as better than yourselves. Let each of you look not to your own interests, but to

the interests of others. Let the same mind be in you
that was in Christ Jesus,
who, though he was in the form of God,
did not regard equality with God
as something to be exploited,
but emptied himself,
taking the form of a slave,
being born in human likeness.
And being found in human form,
he humbled himself
and became obedient to the point of death—
even death on a cross.
Therefore God also highly exalted him
and gave him the name
that is above every name,
so that at the name of Jesus
every knee should bend,
in heaven and on earth and under the earth,
and every tongue should confess
that Jesus Christ is Lord,
to the glory of God the Father.

—**Philippians 2:3-11**

Key Scene: Jesus as Peacemaker

Scene: "Zealots." Fastforward to 1:09:55. Stop after call of two disciples at 1:13:00.

Jesus engages Barabbas in an argument about love and the futility of violence while the Zealot holds a sword to a Roman officer's throat. The angry rebel refuses to heed Jesus' arguments for nonviolent revolution or his desperate plea to save the captive Roman's life.

The Film

Originally shown on CBS-TV, this film adds a number of fictional elements that make it more interesting than the usual Jesus film. It could be subtitled "The Jesus For Peacemakers," as there is a scene fairly early in the film in which Jesus and his disciples are passed by a group of Jewish horsemen. Jesus rushes up just as the guerilla leader is about to slit a Roman's throat. Jesus pleads with Barabbas, arguing that blood and hatred are not the way to free the people. Barabbas, scorning Jesus, advocates force as the way to free the country. He slits the hapless man's throat.

It is the film's depiction of Satan and the temptation stories, however, that make this film particularly good for sparking discussions. After Jesus is baptized and confirmed as the Messiah by his cousin John, he goes into the wilderness to wrestle with the temptations that show us what kind of Messiah he would become. Then, a very non-traditional Satan shows up, first as a scarlet-clad woman demanding that Jesus empty himself of all traces of divinity. An obvious reference to the "kenosis" ("emptying") passage in St. Paul's Letter to the Philippians (See Ch. 2), Jesus shudders and with a rushing sound, his body is wracked. Then, Satan is transformed into a stylishly dressed and groomed man that looks like he stepped out of a fashion magazine. He proceeds to tempt Jesus to choose one of three ways that would win him a following but violate his calling to serve only God.

Luke 4:13 says, *"And when the devil ended every temptation, he departed from him until an opportune time."* Screenwriter Suzette Couture shows us that

this "opportune time" is the moment of agony in the Garden of Gethsemane when Jesus is pouring out his desire to avoid the death looming before him in prayer. What better opportune time would the devil ever find when Jesus' human desire to preserve his life is clashing with the divine Jesus' call to die for the sake of humanity? Satan tries to convince Jesus that if he goes through with God's will for him to die, terrible things lie ahead for humanity. He shows Jesus the dark future of the church's murderous crusades against the Muslims; the cruel Inquisition and witch trials; the carnage of World War I when both sides evoked Christ's name for their cause. All this is true, but the devil is a liar and is sharing only notable failures in Christian history; this devil is not mentioning all of the good Christians have done in the world (a good point of departure for discussion). In the film, the devil urges Jesus to follow a broad, easy path leading away from the Garden and Golgotha.

Catholics will relish this film because Mary has a more central role in Jesus' ministry than depicted in the Gospels. At the end, when the resurrected Jesus takes his leave, she gathers the disciples in what looks like a football huddle to cheer up the group. At the beginning of the film, we also see a lot of Mary's husband, Joseph. It is suggested that it was his foster father's untimely death that acted as the turning point between the private years and Jesus' public ministry. Orthodox Christians have raised plenty of objections to the liberties taken with the biblical accounts, but for those who are open to the depiction of a more human Jesus who dances, laughs, and even plays games with the disciples (they engage in a water fight in one playful scene), this is a satisfying film.

For Reflection/Discussion

Note for group leaders: If you have a print of Ralph Kozak's delightful "Jesus Laughing," place it on display alongside more traditional paintings of Christ to get discussion going.

1. How do the details concerning Joseph add to the human side of Jesus' story? Some have speculated that Jesus' fondness for addressing God as "Abba"— that is "My father" or "Daddy" as it is sometimes translated—grew out of his closeness to Joseph.

2. Almost "the forgotten man" in the Gospels, how does this portrayal of Joseph contribute to our understanding of the formation of Jesus' character? How does his death help explain Jesus ending the private years of his life?

3. What do you think of the way Jesus is portrayed? Traditionally, church teaching and artists have portrayed Jesus as solemn. What do you think of this Jesus dancing, playing and laughing with his disciples?

4. What do you think of the expanded role of Mary, mother of Jesus, given in this film? Compare this with the Gospel accounts to understand this expansion of Mary's role in the movie. Consider reading Mark 3:20-35 as you reflect on this point.

5. If you have both Catholics and Protestants in your group, you might touch off a fascinating ecumenical discussion between the views of Mary in these two major branches of Christianity.

6. Similarly, you may want to discuss Mary Magdalene in this film, which includes details about her that do not appear in the Gospels. In recent decades, many books have been written about the way

Christianity depicts Mary Magdalene. You might want to look at reviews of those books or even select one for supplemental reading. Some Christians today want to see a greatly expanded presence of Mary Magdalene in the story of the church. Others continue to depict her in traditional ways. What do the Gospels actually say about her? An entire discussion could turn on this one character. See my article "Mary Magdalene in Film" in the Spring 2006 issue of Visual Parables.

7. Many scenes in the film can touch off lively conversations. Consider discussing your reactions to the water-into-wine miracle at Cana, for example.

8. One of the richest scenes for discussion is the greatly expanded Temptation in the Wilderness. What do you think about the depiction of Satan as both female and male? Why do you think the scriptwriter included the depiction of Jesus "emptying" himself of his divinity? As you discuss this sequence in the film, consider: While "temptation" is usually thought of as playing on a person's weakness, this Satan plays on Jesus' *strengths*. How do you encounter temptation and wrestle with it? Does Scripture help you to withstand temptation?

9. What do you think of the disciples' doubts about Jesus being the Messiah? Does this take them down out of the stained glass windows and present them as more believable people? Do you feel closer to the disciples as you think about their initial doubts?

10. This film touches on the tension between peacemaking and violence. How do you see that theme portrayed? What do you think about this balance in Jesus' life and teaching? What does the Bible say about these issues?

The Miracle Maker (2000)

TV Movie

MPAA Rating

Not rated

sense of community

Ed's Content ratings (0-10)

Violence **3**

Language **0**

subtitles

↳ chit chat.

Sex/Nudity **0**

Running time

1 hour, 30 minutes

Directors

Derek W. Hayes and Stanislav Sokolov

Major Characters/Voice Cast

Jesus: Ralph Fiennes

Tamar: Rebecca Callard

Jairus: William Hurt

Mary of Nazereth: Emily Mortimer

John the Baptist: Richard E. Grant

Lucifer: William Hootkins

Mary Magdalene: Miranda Richardson
Simon Peter: Ken Stott
Thomas: James Frain
Judas Iscariot: David Thewlis
Caiaphas: David Schofield
Pontius Pilate: Sir Ian Holm
Herod: Anton Lesser
Barabbas: Tim McInnerny
Joseph of Arimathea: Bob Peck
Cleopas: Daniel Massey

Scriptures

Gospel of St. Luke plus:

When they came to the house of the leader of the synagogue, he saw a commotion, people weeping and wailing loudly. When he had entered, he said to them, 'Why do you make a commotion and weep? The child is not dead but sleeping.' And they laughed at him. Then he put them all outside, and took the child's father and mother and those who were with him, and went in where the child was. He took her by the hand and said to her, 'Talitha cum', which means, 'Little girl, get up!' And immediately the girl got up and began to walk about (she was 12 years of age). At this they were overcome with amazement.

—Mark 5:38-42

Key Scene: A Second Temptation Scene

Scene: No. 18 "Your Will Be Done" Time: 1:01:20. Stop at 1:05:59.

After the Last Supper, Jesus and his disciples walk to the Garden of Gethsemane where they meet up

with Cleopas, Jairus and Tamar. Jesus promises that they will be with him in the near future, but he must go for now. Calling Peter, James and John, Jesus goes off and begins to pray to his Father that he can live. At this point, the realistic clay animation, or claymation, changes into flat animation—this being one of the most intense spiritual moments in the film. Seeing a cup suspended in the air, Jesus pleads that he does not have to drink it. In the distance, we see a figure flitting between the trees. It is the toga-clad Satan, tempting Jesus to "just walk away." In a voice displaying his spiritual agony, Jesus refuses. The figures are again portrayed in claymation as Jesus rejoins his disciples and chides them for sleeping. Soon, Judas and the guards are arresting Jesus, with the "miracle worker" healing the slashed ear of the servant injured by the sword of one of the disciples.

The Film

Unlike Pasolini's film, this one directed by Derek W. Hayes & Stanaslav Sokolov combines elements from all four Gospels, not just one. An animated film of great artistic merit, it is well suited for family viewing and discussion. With marvelous backgrounds and intricately wrought buildings, some of the frames from the film could be displayed as paintings.

The story is told through the eyes of a child, Tamar, the daughter of Jairus whom Jesus cured. She and her father become friends of the wandering rabbi and are present at many key moments in Jesus' life. About the same length as the average animated feature that children love to watch over and over, it poses no danger of a child becoming bored.

Ralph Fiennes as the voice of Jesus captures the warmth, humor and agony of Christ—his reading of

the words of Jesus' Garden of Gethsemane prayer are one of the most moving in any of the Life of Jesus films. Another artistic plus is the shift from stop-motion animation to drawn animation whenever there is a flashback or a scene that depicts an inward, spiritual nature. An example of the latter is seen in the two incidents in which Satan comes to Jesus, during the wilderness temptation and in the Garden of Gethsemane.

The scriptwriters make Mary Magdalene a central character, showing her near the beginning of the film having a brief encounter in Seporah where Jesus is working as a carpenter before beginning his public ministry. She is either an epileptic or has a mental disorder, wandering the streets and creating a commotions with her ranting. When the overseer on the building crew starts to drive her away with a whip, Jesus restrains him and helps her up from the ground. She flees, but they meet later, whereupon Jesus drives out the seven demons from her. This sequence is also shown in flat animation. Later, she disrupts a feast at a house where Jesus is a guest. The filmmakers follow the misguided tradition of identifying her as the sinful woman wiping his feet—an issue in Bible scholarship you will find covered in detail in recent books about Mary Magdalene. And then later, we see her in the upper room where Jesus dines with his disciples.

This depiction of the Last Supper is interesting because the room is set with three tables along one end of the room for Jesus and the disciples and two smaller round tables at which Jairus' family, Mary Magdalene and some other followers sit. Thus, Tamar is able to witness the Last Supper. This also makes sense of having Jesus and the disciples all sitting on

one side and the ends of the long table so that they can see and be seen by the other guests.

Many miracles are shown, such as the raising of Lazarus, giving rise to the film's title. One could wish that more of Jesus' teachings could have been included, but this, of course, is impossible given its rather short duration. However, I must say that the two included parables—the one about houses built upon a rock and upon sand and the other about the Good Samaritan—are memorably depicted, again in flat animation.

A few non-biblical scenes involving Roman soldiers and Pilate provide a glimpse into the political situation in Judea.

While this is too brief for as complete a picture of the life of Christ as I would prefer, nonetheless this is one of my favorite Life of Jesus films. If I could have only two "life of Jesus" films, this would be the one for me, along with Zefirelli's masterful *Jesus of Nazareth*.

For Reflection/Discussion

1:15

1. What do you think of the use of a little girl as a narrator, given that this is a movie for children?
2. Compare the unique physical appearance of Jesus in this movie with actors who have portrayed him. How do you respond to the two forms of animation used in this movie?
3. This film is relatively short. Discuss the scenes the filmmakers decided to include versus those omitted from the film. Can you see reasons for these choices? Do you agree with the filmmakers selections?
4. Compare the character and message of Jesus as shown in this film with other movies you are

watching in this series. For example, how do we first see the compassion of this Jesus?

5. As in the questions I raise about *Jesus* (1999), this is another good opportunity to discuss the complex role of Mary Magdalene in Christian history. Do you realize that there is an early Gnostic writing called *The Gospel of Mary*, referred to by some as *The Gospel of Mary Magdalene*? See the interesting Wikipedia article "The Gospel of Mary."

6. The depiction of Satan also is an intriguing point to compare between this movie and *Jesus* (1999). What does this film suggest is the larger meaning of the temptations? How did you respond to the inclusion of temptation in the Gethsemane sequence?

7. Judas is another good choice to highlight in this film. Consider reading John 12:5-7, one of Judas' key scenes in the Gospels as part of this discussion. How does the Judas in this film compare with your impressions of him?

8. In the scene of the cleansing of the temple, how is it a good thing to see that Jesus became angry? What does this tell us about his nature? When is anger a good and not a bad thing? (Think about the prophets: what were they angry about?)

9. Remember that this film was intended for children. What do you think of the way the crucifixion and events leading up to it are depicted? How about the resurrection sequence? If you have parents in your group, talk about the challenges of conveying the Gospel stories to children. If you are talking with youth, ask about how their impressions of Jesus have changed and how they compare with what we see in this movie?

10. Consider discussing this film with children, perhaps your own—or perhaps a group of families would enjoy gathering to watch the film together. Talk with Christian educators in your congregation about scheduling a viewing of this movie with children and their parents. Remember that children like to express themselves with drawings, often more than with words. After viewing the film, ask kids to draw their favorite scene—and then explain their sketches to the group. Most kids are happy to show their drawings and explain them if adults seem interested in their work—and this process is guaranteed to provide cross-generational insights.

ask about the miracles

what Jesus' mother

CHAPTER 4

The Visual Bible: The Gospel of John (2003)

MPAA Rating

PG-13

Ed's Content ratings (0-10)

Violence **3**

Language **0**

Sex/Nudity **0**

Running time

2 hours, 5 minutes

Director

Philip Saville

Major Characters/Voice Cast

Narrator: Christopher Plummer

Jesus: Henry Ian Cusick

Simon Peter: Daniel Kash

John: Stuart Bunce

Andrew: Tristan Gemmill

Philip: Andrew Pifko
Nathanael: Elliot Levey
Judas Iscariot: Alan Van Sprang
Virgin Mary: Diana Berriman
Mary Magdalene: Lynsey Baxter
John the Baptist: Scott Handy
Leading Pharisee: Richard Lintern
Pontius Pilate: Stephen Russell
Nicodemus: Diego Matamoros
Caiaphas: Cedric Smith
Samaritan Woman: Nancy Palk
Blind Man: Stuart Fox
Thomas: Andy Valasquez
Martha: Miriam Brown
Mary, sister of Lazarus: Miriam Hughes

Scriptures

The Gospel of St. John (The Good News Bible version) especially:

And the Word became flesh and lived among us, and we have seen his glory, the glory as of a father's only son, full of grace and truth.

—*John 1:14*

This is the disciple who is testifying to these things and has written them, and we know that his testimony is true. But there are also many other things that Jesus did; if every one of them were written down, I suppose that the world itself could not contain the books that would be written.

—*John 21:24*

Key Scenes: "The Promise of the Holy

Spirit" and "Love One Another"

(Disc 2-the scenes are not numbered.) Starts at 21:36. Stop at 27:45 (cue words, "Whoever hates me, hates my father also." Note that I am referring to the three-disc set. If you have just the one-disc version, then the Scripture chapter you start with is Ch. 14:15-31.

We see stars overhead at the beginning of this portion of the Upper Room Discourse because Jesus and the disciples have gone up to the roof where he continues to address them about the Holy Spirit, his Father and love. Those who have not seen this video before might be surprised to see a woman present throughout the discourse, Mary Magdalene. The camera moves around, resting upon one face after another. When Jesus speaks of the peace he gives, he takes each person's hand, one at a time. When he speaks of the ruler of this world coming, the camera switches to Judas going to the high priest to betray his master. The scene then switches to a vineyard, where Jesus speaks of vine and branches. Jesus then leads the band down a steep path as he continues to speak of love. Before the end of this segment, there are flashbacks to his calling the disciples and the attempt to stone him in the temple. Thus, by creative editing, the filmmakers move the action out of the confines of the room where Jesus washed his disciples' feet and go back to earlier scenes (in faded color). By doing this, the director and editor make what seems like a section of the Gospel impossible to film—John 13-17—visually interesting.

The Film

During the controversy over Mel Gibson's *The Passion of the Christ*, another film quietly slipped into theaters on a regional basis around the country. It is a

beautifully crafted version of *The Gospel of John* that drew praise wherever it played. Deservedly so. No one need complain that extraneous, violent material was added, as was the case in the old potboilers of the 1960s: *King of Kings* and *The Greatest Story Ever Told*. This two-hour epic is word for word a screen adaptation of the text of the American Bible Society's Good News Bible read by the great actor Christopher Plummer. Screenwriter John Goldsmith's contribution must have been the excellent directions for the way in which the cast acted out the biblical text.

A Canadian-British production, *The Visual Bible: The Gospel of John* is imaginatively directed by Philip Saville, who knows how to keep our interest during the long speeches that are so unique to St. John's Gospel. Actor Henry Ian Cusick is perhaps the finest movie Jesus yet to appear, the Shakespearean actor bringing both a sense of divine dignity and down-to-earth humanity to the role. It helps that the actor is not well known to American audiences.

St. John's is the one Gospel in which Jesus boldly asserts his divinity in public. This is portrayed by the actor in a believable style. He is also often shown smiling and picking up a child during his public appearances, and his attendance at the wedding in Cana shows his love of life and laughter. In regard to the miracle at the wedding, and other miracles, the director wisely follows the lead of Pasolini's *Gospel According to St. Matthew* by refusing to indulge in showy spectacle. One moment it is water in the jugs, and then it is wine when dipped out by the wine steward. The same treatment is accorded the appearance of the angels to Mary Magdalene at the empty tomb. She "sees" the supernatural beings; we

see only the play of light on the garments laid out on the stone.

A good touch at the beginning of the film shows the sun rising and John the Baptist (Scott Handy) preaching and baptizing. When the Word is mentioned in the prologue, there are several inter-cut shots of the shadow and sandaled feet of a man walking toward the river. But it is not until verse 14, "*And the Word became flesh*," that the camera reveals the full figure of Jesus. Another good technique that keeps our eyes busy during the long discourse of Jesus in the Upper Room is the frequent use of flashbacks at appropriate places. The film also appropriately depicts Jesus' mother, Mary (Diana Berriman), at the wedding and at the cross as the mature woman she would have been, rather than as the youthful Madonna so often portrayed in the Hollywood films.

A preamble before the title appears, informing the audience that St. John's Gospel is believed to be the last of the four Gospels written some two generations after Jesus walked the land. Written at the time when Christianity was separating from organized Judaism, the Gospel reflects the controversy of this later conflict. This is helpful because St. John is the Gospel most open to mistaken anti-Jewish interpretations because of references in the Gospel to tensions between Jewish groups as Christianity emerged.

Among the refreshing scenes in this film: I was reminded anew by the joyfully running woman at the well rushing to tell her fellow Samaritans the news about Jesus—a *woman* was the first evangelist, even as later we see that the first witness to the resurrected Christ was also a woman.

Among the actors in this film, I want to call attention to Daniel Kash, who is excellent as Peter, especially in the denial and the post-resurrection forgiveness scenes. Stephen Russell as Pontius Pilate and Richard Lintern as one of the leaders of the Pharisees handle their thankless task of portraying the opposition well. The PG-13 is mainly because of the brief scene of violence leading up to and including the crucifixion—these are brief because John himself emphasizes more the divine Jesus and the transcendent Christ, rather than the human sufferer. Also, there is mild violence during the cleansing of the temple when Jesus so vehemently lashes out at the sellers and overturns the tables of the money changers, that proponents of a "gentle Jesus, meek and mild" might be surprised.

The Gospel of John is the third of the Visual Bible films that I have reviewed. *The Gospel According to St. Matthew* and *Acts* were also word-for-word dramatizations of New Testament books, but used the New International Version (NIV) translation. I prefer the Good News Bible text used in *The Gospel of John* because the dialogue retains more of the dignity of the original but also has a naturalness that we would expect in conversations in the marketplace or the precincts of the temple.

These producers had a bigger budget than some of the other Jesus films, and it shows in the sets and in the magnificent vistas we see of the Jerusalem skyline and the impressive temple, plus some computer-generated backdrops. Multiple formats of this film have been released for home viewing, so check around before making your final choice.

For Reflection/Discussion

1. A number of excellent books have been published
 in the past two decades helping Christian readers
 understand Jesus and the early Christian movement
 within the context of first-century Judaism. Talk
 with local clergy or contact a regional interfaith
 group and ask about these issues in *The Gospel of
 John*, which historically led to mistaken anti-Jewish
 interpretations of John's message. Since the 1960s,
 Catholic and Protestant denominations have been
 asking congregations to properly understand that
 Jesus and his followers were Jewish and that care
 needs to be taken in sorting out these issues. If you
 do wish to talk about this subject, you might plan
 ahead and organize an interfaith conversation or
 invite participants to read and summarize portions
 of some of these more recent books about references
 to Judaism in *The Gospel of John*. This is a challenging
 discussion, but it also can be an important learning
 experience.

2. There are also other topics to discuss after viewing
 this film. For example, this is a good film to compare
 with famous paintings of scenes in Jesus' life. This
 is also a good film to raise the question of Jesus'
 humanity and divinity. You could discuss miracles
 after watching this film. And the depiction of Mary
 Magdalene, once again, could spark some lively
 conversation.

3. You might focus on major incidents depicted in this
 film from *The Gospel of John*: baptism, temptation,
 clash with the opposition, Last Supper, trial,
 crucifixion, resurrection. Compare the filmmakers'
 treatment of these scenes with the text of John and
 with your own assumptions about these scenes. Did

these scenes surprise you? Disappoint you? Inspire you? Encourage appropriate discussion between disagreeing group members.

4. The construction of the Last Supper sequence could fuel an entire discussion. What do you think of the way the filmmakers used flashbacks in the middle of this sequence? How effective was this in keeping your interest? Because John does not depict Christ instituting a sacrament of the Last Supper, how do these scenes compare with the Upper Room/Last Supper text in John and in the other Gospels?

5. The depiction of Judas is noteworthy. How did this Judas compare with the Judas characters in other films in this series? In this case, the filmmakers paint his motives as particularly evil, as opposed to suggesting that Judas was merely mistaken or misguided.

6. What do you think of the dramatic Easter stories in this movie? Why might Jesus have asked Peter three times did he love him? Anything to do with the disciple's three denials? How does John's version enrich our understanding of Easter?

7. Do you find this depiction of Jesus satisfying, overall? What would add or take away from it? How does this film, based on this Gospel, add to our growing mosaic of Christ?

8. Ask the group to list the "I am" passages in John: what does each add to our understanding of the nature and work of Christ? Why do you think none of the other gospel writers include even one of these? Could it be that John, writing several decades after Jesus' death and resurrection, crafted these passages himself as summing up who Jesus was (and is)?

CHAPTER 5

The Passion of the Christ (2004)

(Aramaic and Latin with English subtitles)

MPAA Rating

R

Ed's Content ratings (0-10)

Violence **9**

Language **0**

Sex/Nudity **3**

Running time

2 hours, 7 minutes

Director

Mel Gibson

Major Characters/Cast

Christ: Jim Caviezel

Mary: Maia Morgenstern

Peter: Francesco De Vito

Judas: Luca Lionello

Mary Magdalene: Monica Bellucci

Pontius Pilate: Hristo Shopov

Caiaphas: Mattia Sbragia

Annas: Toni Bertorelli

Who has believed what we have heard?
And to whom has the arm of the LORD been revealed?
For he grew up before him like a young plant,
and like a root out of dry ground;
he had no form or comeliness that we should look at him,
and no beauty that we should desire him.
He was despised and rejected by men; a man of sorrows,
and acquainted with grief;
and as one from whom men hide their faces
he was despised, and we esteemed him not.
Surely he has borne our griefs
and carried our sorrows;
yet we esteemed him stricken,
smitten by God, and afflicted.
But he was wounded for our transgressions,
he was bruised for our iniquities;
upon him was the chastisement that made us whole,
and with his stripes we are healed.
All we like sheep have gone astray;
we have turned every one to his own way;
and the LORD has laid on him
the iniquity of us all.

—*Isaiah 53:1-6*

You were bought with a price...

—*1 Corinthians 7:23*

There is a fountain filled with blood/Drawn from Immanuel's veins;

And sinners, plunged beneath that flood,/Lose all their guilty stains…

—**From the hymn by William Cowper**

Key Scene: Tempted in the Garden

Scene: Start at beginning of the film and stop at 9:30.

After the studio icon, the words from Isaiah 53 appear, *"He was wounded for our transgressions …"*. In the most detailed depiction of the Agony in the Garden of Gethsemane, we see the shadowy figure of Jesus praying quietly in Aramaic. Subtitles provide the English text. Ominous music plays throughout this sequence. Jesus goes to rouse his sleeping disciples. They ask him if they should flee, but he tells them to stay and watch with him. As he leaves them, they note that he seems afraid. Cut to the priests in the temple where Judas receives the pouch of 30 pieces of silver, which they throw contemptuously at him. Back to the Garden where three disciples follow their master at a distance to watch him. Jesus is troubled. Sinking to the ground and quoting from Psalms, Jesus prays that God will defend him. We catch a glimpse of a hooded figure behind him. As in *The Miracle Maker* and the TV miniseries *Jesus*, it is Satan returning to tempt Jesus, declaring that no man can carry the burden of mankind's sins. As Jesus prays that his Father will take "this chalice" from him, we see from beneath Satan a snake crawl forth. It approaches Jesus. As it slinks to him, he slowly rises, glances at Satan, and stomps on the serpent. He stares again at Satan, and then at the three disciples. In the distance we see the torches of the party coming to arrest him.

The Film

Mel Gibson affirms with the apostle Paul that we were "bought with a price" through Jesus' death. That is language Paul uses in 1 Corinthians 7—and Mel Gibson is saying to moviegoers: "Look! For the next 127 minutes I am going to show you just how great that price was—the very agony and blood of our Lord Jesus!"

Many viewers would describe this film as an almost unrelieved orgy of cruelty, so you should discuss with friends whether everyone wants to see this film. It's not a movie for the sensitive—and definitely not for children!

At a little over two hours in length, Gibson's film has plenty of time to indulge in virtually every blow inflicted upon Jesus from the beginning when Jesus is seized in Gethsemane by temple guards and beaten along each step of the way. Drawing upon the gory visions of Sister Anne Catherine Emmerich, a German nun who lived two centuries ago, Gibson has the enchained Jesus thrown over a bridge. He dangles helplessly in the air above the water until the guards haul him up like some large fish.

These details come from a book called *The Dolorous Passion of Our Lord Jesus Christ*, which was assembled and published by her friend Clemens Brentano in 1833, a decade after Emmerich's death in 1824. Gibson admitted using this book, which he described as a widely accepted version of what happened during Jesus' final days. Bible scholars point out that Emmerich's book contains many details about Jesus' trial and death that never appear in the New Testament; historians explain that Emmerich's spiritual visions were intended

for inspirational purposes and were not meant to be reliable historical accounts. To complicate the matter, the so-called Emmerich texts were collected and published in book form years after her death and questions have arisen about the sources and the accuracy of the book. Some wonder whether her visions were properly recorded by Brentano; others have questioned whether he borrowed from other sources in producing the book. Pope John Paul II beatified Emmerich in 2004, moving her along the pathway toward canonization as a saint—but the Vatican made a point of saying this determination was based on the example of her life of piety and not on the accuracy of the book that bears her name. Overall, Gibson's claims about the accuracy of the scenes in this film should be questioned in any discussion of the film.

How violent is this film? During the scourging, pieces of Jesus' flesh appear to be torn away. Rods used to beat him are replaced by leather flails with tips of glass and stone. You won't easily forget these scenes after you have seen them, which was Gibson's intention.

Gibson did make a few changes to this film in response to strong criticism that it would encourage anti-Jewish stereotypes. If you decide to view and discuss this film, search online for some of the reporting about the movie's release. Around the time of its debut in 2004, The New York Times columnist Frank Rich, who is Jewish, wrote several columns criticizing Gibson's film and Gibson's overall behavior that year. The Wikipedia page for this film has a long section explaining several controversies surrounding the film's release with footnotes that link to other magazine and newspaper coverage.

If you do view this movie, you will discover a number of secondary characters who do not appear in the Bible or are barely mentioned. This includes a young woman who wipes Jesus' face with a cloth—instantly recognizable to Catholic viewers as Saint Veronica. Veronica is never mentioned in the New Testament, but is popular in Catholic tradition and memorialized in the sixth Station of the Cross in Catholic and many Anglican churches. This kind of detail in Gibson's film can spark fascinating ecumenical discussions. Most Protestants have never heard of Veronica and will be surprised to learn that many Catholics assume Veronica is part of the Bible's Passion story.

While the violence in the movie makes it problematic for discussion groups, I believe there are some fascinating juxtapositions that Catholic and Protestant viewers will find quite enlightening in an ecumenical setting. For example, Gibson intentionally shaped his scenes to line up with his theology of the Mass as a sacrificial meal. Consider talking about that theme across Catholic-Protestant lines.

The movie also is an opportunity for cross-cultural conversations. Search for images of Christ's Passion from communities in the Southern Hemisphere, where brutality and oppression is often a more common experience than in the U.S. In many cases, crucifixion imagery is far more graphic in these Christian cultures.

The Passion of the Christ is not for everyone, but its release has been the occasion for taking another look at the crucified Christ—and the meaning of that moment in history for the world's 2 billion Christians.

All the debate and discussion that have arisen show that movies do matter in our media-saturated culture. Even more, as Christians, we can take heart that our Savior is still relevant in a post-Christian age.

For Reflection/Discussion

1. Any group discussing this film will want to begin by expressing emotional responses. What feelings well up during the film? And, what feelings are you experiencing after watching it? Are you glad you viewed the film? Do you feel it was a helpful or inspiring experience?

2. Discuss the graphic violence in the film. Was it simply too much? Or are there religious or cultural reasons that could justify some of Gibson's choices? How different is this violence than scenes in current video games? Or scenes in popular R-rated horror movies? Or scenes in hit TV series about zombies? There is no right or wrong answer to these questions, but this is an opportunity to discuss how participants feel about the prevalence of graphic violence in so much of our popular culture.

3. How would you describe Gibson's overall message in the film? Is it possible to separate the impact of the violence from other themes Gibson was trying to convey?

4. Read Isaiah 52:13 to 53:10. Do you think Gibson's film captures the meaning of this suffering servant passage? Do you think that the brief scene at the end of the film is enough of an exposition of 53:11-12?

5. Gibson accepts one interpretation of the crucifixion known as substitutionary atonement, which basically means that Jesus had to die as a substitute for others. A lengthy Wikipedia article about "substitutionary atonement" outlines various versions of this

traditional teaching, which some denominations continue to preach today. You might ask local clergy or lay leaders to explain how they understand this idea. After viewing the movie: What do you think of substitutionary atonement? How do you understand the complex motives behind Jesus' crucifixion?

6. Many of the secondary characters in this film can spark conversation in your group, including Veronica. Choose two or three that intrigue you. Look for traditional paintings or other depictions of these characters as a point of comparison. And, compare these depictions with other films in this series. For example: What do you think of the portrayal of Judas? Or: Who is the androgynous character we see dimly in the Garden of Gethsemane and then moving through the crowd watching the scourging of Jesus?

7. Early in the film, in the Garden of Gethsemane scene, a snake slithers across the ground and Jesus stomps on it. What is the meaning of this? Look at Genesis 3:14-15 as you explore the biblical basis for this traditional Christian idea.

8. Because Gibson's film is so strongly influenced by traditional Catholic teaching, the director's depiction of Mary is intriguing, especially if your group includes both Catholics and Protestants. What do you think of Gibson's Mary? Is this Mary familiar to you from your own family or church background?

9. Bring in illustrations or a booklet depicting the Stations of the Cross and discuss how Gibson's film parallels this centuries-old form of spiritual discipline. Have members of your group ever experienced the Stations of the Cross? Your group might have an opportunity to meet in a church with

a set of stations mounted on the walls. Ask clergy or lay leaders to give your group a tour of the images. Which stations are referenced in the Gospels? Which stations seem to be missing in the biblical text? How many appear in Gibson's film?

10. As with other films in this series, you could tackle Christian-Jewish issues raised in Gibson's movie. As I have suggested earlier, please consider reaching out to an interfaith group in your area or consult local religious leaders or recent books to help you with this challenging conversation.

11. In Protestant churches, you may want to consult older hymnals and discuss hymns that emphasize bloody imagery as a metaphor for salvation. One such hymn is popularly known as "There Is a Fountain Filled with Blood," written by William Cowper in the 18th century. Aretha Franklin recorded a version of the hymn in the 1950s; other audio versions of the song are available, as well. What is the role of such bloody imagery in Protestant tradition?

12. Some critics accused Gibson of not providing any context from Jesus' prior life for us to sympathize with him during the scourging and crucifixion. However, when I checked the DVD, I found that there were 13 flashbacks to earlier events, most of them to the Upper Room activities; but one to childhood; another to Mary Magdalene; also to his entrance into Jerusalem; and even a humourous one to his making chairs and a higher than usual table (Mary says, "It will never catch on"). Many of these are very short, so it is very easy to let them slip by. How do these scenes evoke your sympathy?

CHAPTER 6

Son of God (2014)

MPAA rating

PG-13

Ed's Content Ratings (0-10)

Violence **6**

Language **4**

Sex/Nudity **1**

Running time

2 hours, 18 minutes

Director

Christopher Spencer

Major Cast/ Characters

Jesus Christ: Diogo Morgado

Mary, Mother of Jesus: Roma Downey

Young Mary: Leila Mimmack

Joseph: Joe Coen

John: Sebastian Knapp

Simon Peter: Darwin Shaw

Thomas: Matthew Gravelle

Judas Iscariot: Joe Wredden

Mary Magdalene: Amber Rose Revah

Nicodemus: Simon Kunz

Simon the Pharisee: Paul Marc Davis
Caiaphas: Adrian Schiller
Pontius Pilate: Greg Hicks

For God so loved the world that he gave his only Son, so that everyone who believes in him may not perish but may have eternal life.

—*John 3:16*

See, I am coming soon; my reward is with me, to repay according to everyone's work. I am the Alpha and the Omega, the first and the last, the beginning and the end.

—*Revelation 22:12-13*

Key Scene: A Night of Prayers

Scene: On the DVD the scenes are not named. This is No. 23. It begins at 1:16:13 and ends at 1:21:45.

It is night as the camera pans over the rooftops of Jerusalem. At the temple, Caiaphas sends Judas and a contingent of guards to arrest Jesus. In the Garden of Gethsemane, Jesus announces: "The time has come. The spirit is willing, but the flesh is weak." Mary Magdalene is present with Peter—we are not shown who else is there. Cut to Judas, with the guards drawing near. It looks like he is in custody, rather than leading the group. The agonized Jesus prays a short version of the familiar "Take this cup from me" prayer. As he pleads, "Spare me," the scene switches to the temple where Caiaphas is also praying. But what a different sort of prayer, "Lord, I know you are pleased with me, for you sustained me in sincerity." Then there is a switch to Pilate's praying wife Claudia, thanking their ancestors for watching over them. Back to Caiaphas and his fellow priests in the temple,

and then to the arresting party entering the Garden. In a very close-up shot, Jesus prays, "If you will it, Father..." (Nothing is shown of Jesus going to the sleeping disciples and rebuking them.) Immediately after the guards arrive, Judas approaches his master as Peter stares in disbelief. When the betrayer kisses Jesus, Peter yells, "**Traitor!**" and knocks Judas down. Scuffling with the guards, Peter shouts over and over, "Run, Jesus, run!" He manages to draw his sword and slash off a servant's ear. Jesus calls a halt, saying to Peter, "He who lives by the sword, dies by the sword." His healing of the servant's ear is a very dramatic moment, after which the guards thrust a bag over Jesus' head and take him away. The disciples run away, leaving Peter to follow after his master.

The Film

The film begins with John, identified as the disciple and the author of the Apocalypse of John (many scholars believe they were two separate persons), quoting himself, "*In the beginning was the Word, and the Word was...*" While John is speaking, we see a series of snippets from The Bible: Adam and Eve, Noah, Abraham, Sampson, David and Goliath, the Nativity, and the visit of the Magi.

Following the title, the scene shifts to Prefect Pontius Pilate impatiently making his way with his wife, Claudia, and retinue toward Jerusalem. We see just how cruel he can be when he orders his men to push a broken-wheeled cart off the road. They do so before the parents can snatch their young son out of it, and the cart crushes the lad in the fall. The Roman column passes by with no concern for the child or his grieving parents. This is one of many occasions that result in the filmmakers' being a bit heavy

handed—they overdo the musical accompaniment, allowing for little actual reflection on a scene. In this way, the music virtually tells us what to feel.

Jesus walks toward the Sea of Galilee where he finds Peter trying unsuccessfully to catch fish. Jesus shows Peter where to find a big catch, then calls him to come "change the world." The film seems to rush through the events of Christ's ministry in Galilee, stressing his miracles more than his teachings. The early opposition to Jesus is largely embodied in one character, Simon the Pharisee, whom we first see becoming upset when some of the people he is teaching spot Jesus nearby and rush out to greet him. Simon's obvious jealousy is quickly joined by his anger and accusation of "Blasphemy!" when he watches Jesus first forgive the sins and then heal the paralytic. In the course of the film, Simon gets around a lot— his hatred of Jesus grows as the Galilean continues to press his claims to be the Messiah.

Like Zefirelli in his masterful *Jesus of Nazareth*, the filmmakers skillfully rearrange the gospel materials. Jesus is standing before the tax collector's table while the disciples and Simon look on with obvious disapproval. Jesus tells his parable of The Tax Collector and the Pharisee as he looks at Matthew (as with Simon Peter, this film does not show a before and after conversion name for the pair). When the tax collector in the parable says "Lord, have mercy on me," Matthew (his eyes tearing up) also says the prayer, and Jesus, noticing this, calls: "Matthew, come!"

I appreciated the depiction of Mary Magdalene as one of the band of disciples. There seems to be a new

feminist consciousness among filmmakers, with such films as *Jesus* (1979); *Jesus Christ Superstar*; *Jesus the Miniseries*; *The Gospel of John*; and *The Miracle Maker* also showing Mary participating in more than just the incidents at the cross and the empty tomb. This also is in keeping with Luke 8:2, which states that Mary and a group of other women accompanied Jesus and the disciples—caring for their needs. (For a detailed examination of Mary Magdalene in all the previous Jesus films see my article in the Spring 2006 issue of *Visual Parables*, "Mary Magdalene in Film: In Response to *The Da Vinci Code*.")

This film was rated a low 38 out of 100 on the Metacritic site and just a measly 25 percent on Rotten Tomatoes, which seems grossly unfair. This suggests that this is a film directed to the choir, rather than one that will appeal to the unconverted—even though it is clearly more evangelical in intent than the other Jesus films. The film ends with John telling his colleagues, "My brothers, we have work to do," with a similar message included in narrator John's vision of the risen Christ quoting the "Alpha and Omega" passage from The Apocalypse of John.

For Reflection/Discussion

1. New movies about Jesus continue to be produced each year, and a recent TV debut, based on Bill O'Reilly's book *Killing Jesus*, set new viewer records for the National Geographic Channel. Clearly, movies about Jesus are as popular as ever! This movie you've just watched, *Son of God*, is one of the most recent portrayals seen around the world. So, this is a good opportunity to compare this movie's depiction of Jesus with other Life of Jesus Films in this book. Additionally, compare this film with others you may

have seen recently on TV, like *Killing Jesus.* What incidents in each movie bring out the humanity of Jesus? What scenes in each film bring out the divinity of Jesus? Is Jesus mostly somber? Does he smile? What about the ethnicity of the actors playing Jesus in these various films?

2. Beyond Jesus, consider other characters: Pilate, the disciples, the women around Jesus and so on. Consider searching online to find movie stills of the actors and the roles they are portraying in these films. Zero in on one character and show movie stills of that character as portrayed by several actors. Take time, especially, to discuss the portrayal of Mary Magdalene, whose popular image has changed dramatically over the years. In this version, Mary Magdalene's role is highlighted in a more positive way than we've seen in other Life of Jesus films. When talking about Mary Magdalene, be sure to discuss events after the crucifixion.

3. Using your Bibles as reference, once again, compare details the filmmakers have left out, as well as details they have added or changed. For example, this film leaves out the Temptation in the Wilderness. Why? How does that change our impression of Jesus in this version? In this film, Jesus' agony in the Garden contains some details from Scripture and then adds others. Look at the way the crowd is persuaded to ask for the crucifixion of Jesus, as shown in this film. How does that compare with Scripture? And discuss the "Pieta" scene in this movie, which you could compare both with Scripture and with the many portrayals by painters and sculptors. You'll find countless images online of Pieta portrayals by Michelangelo and other artists.

4. Compare the treatment of the trial, flogging and crucifixion scenes with those in Mel Gibson's *The Passion of the Christ*. No bird gouging out the thief's eye in this movie! And yet, is this version any less effective in showing us the suffering Christ? Based on these scenes, discuss the filmmakers' assumptions about whether God ultimately is a loving creator or a vengeful judge.

5. What do you think of the film returning to John at the end? Of all of the 12, why is he the choice to be telling the story of Jesus?

6. This movie was made from a portion of a larger TV miniseries called, *The Bible*. Some Americans saw that original miniseries, but some may not have seen the whole thing. Find someone who did see the original miniseries and ask them to describe comparisons with this shorter movie about Jesus. Many newspapers and magazines have published articles about the production of the miniseries and this movie, including news stories, interviews and reviews. Consider sharing some of that coverage with people in your group. Some coverage has been very positive; some coverage has been highly critical. What do you think about these viewpoints from news media? What does this coverage say about how the portrayal of Jesus in popular culture is continuing to evolve? I also wrote a series on *The Bible*, which can be found on my blog at: http://www.readthespirit. com/visual-parables/the-bible-first-week/.

7. After they find the tomb empty, what does Peter do in the market? What is he doing with the bread and wine, and who shows up behind him almost immediately? What are the filmmakers saying by this about the Lord's Supper or Eucharist?

PART 2

"Jesus Transfigured" Films

Jesus Christ Superstar (1973)

MPAA rating

G

Ed's Content ratings (0-10)

Violence **3**

Language **0**

Sex/Nudity **5**

Running time

1 hour, 48 minutes

Director

Norman Jewison

Music

Andrew Lloyd Webber

Major Characters/Cast

Christ: Ted Neeley

Judas Iscariot: Carl Anderson

Mary Magdalene: Yvonne Elliman

Simon Zealotes: Larry Marshall

Peter: Paul Thomas

Pontius Pilate: Barry Dennen

Caiaphas: Bob Bingham
Annas: Kurt Yaghjian
King Herod: Josh Mostel

Many of the Jews therefore, who had come with Mary and had seen what Jesus did, believed in him. But some of them went to the Pharisees and told them what he had done. So the chief priests and the Pharisees called a meeting of the council, and said, 'What are we to do? This man is performing many signs. If we let him go on like this, everyone will believe in him, and the Romans will come and destroy both our holy place and our nation.' But one of them, Caiaphas, who was high priest that year, said to them, 'You know nothing at all! You do not understand that it is better for you to have one man die for the people than to have the whole nation destroyed.' He did not say this on his own, but being high priest that year he prophesied that Jesus was about to die for the nation, and not for the nation only, but to gather into one the dispersed children of God. So from that day on they planned to put him to death.

—John 11:45-52

The next day the great crowd that had come to the festival heard that Jesus was coming to Jerusalem. So they took branches of palm trees and went out to meet him, shouting,
'Hosanna!
Blessed is the one who comes in the name of the Lord—the King of Israel!'
Jesus found a young donkey and sat on it; as it is written:
'Do not be afraid, daughter of Zion.

Look, your king is coming,
sitting on a donkey's colt!'
His disciples did not understand these things at first;
but when Jesus was glorified, then they remem-
bered that these things had been written of him
and had been done to him. So the crowd that had
been with him when he called Lazarus out of the
tomb and raised him from the dead continued to
testify. It was also because they heard that he had
performed this sign that the crowd went to meet
him. The Pharisees then said to one another, 'You
see, you can do nothing. Look, the world has gone
after him!'

—*John: 12:12-19*

Key Scene: Tempted on Palm Sunday

Scene: No. 6 "Simon Zealotes." Start at 29:40. Stop at
35:37. Visual clue: At end of Jesus' song, a close up on
Simon's face, then Jesus

As his nickname indicates, this Simon (as opposed
to Simon Peter) is a member of the Roman-hating
Zealots, who long for a leader to start a revolt against
the arrogant Romans occupying their land. Amidst
the enthusiasm of the crowds welcoming Jesus to
Jerusalem, a dancing Simon urges Jesus to take
advantage of the moment. Just "add a touch of hate
for Rome," he says, and the crowd will follow Jesus
until he achieves "the kingdom, the power, and the
glory." Jesus slowly and calmly sings that none of
them know what those three are, that to achieve
them, "you only have to die."

The Film

When Andrew Lloyd Webber and Tim Rice
released their rock opera as a two-record album

in 1970, it was banned by the BBC as sacrilegious. However, *Jesus Christ Superstar* quickly became a huge hit in the U.S. and sparked stage productions in New York City and other parts of the world.

Norman Jewison produced and directed this movie version of the rock opera, which was released in 1973. The plot borrows material from all four Gospels and is most unusual for the prominent roles of Judas and Mary Magdalene. The depiction of Judas is daring because the betrayer becomes more of a tragic figure in this rock opera than his traditional casting as simply evil or a member of the revolutionary Zealots.

Ted Neely plays a rock star Jesus, deeply troubled by his understanding that God wants him to die. This was the first major film to take seriously the human side of Jesus' nature—even suggesting that he might have been sexually attracted to women like Mary Magdalene or that he might lose his temper when pressed too hard by the crowds. This was too much for many conservative church members, who did not like the sexual implications of the song "I Don't Know How to Love Him" sung by Mary Magdalene. Christian critics also sorely missed a resurrection scene, but the film nevertheless attracted many young people and sent them back to read the source: the Gospels.

Ted Neely's Jesus is a thin, ascetic looking Jesus with a high singing voice—very different from other portrayals of the Nazarene. At times, he seems victimized by circumstances rather than portrayed as the strong Son of God envisioned in the Gospel of St. John. This is the way Judas sees his master, as he is fearful that "all this talk of God" has gone to Jesus' head. Thus Judas is as much, maybe more, the central

character, even though Jesus gets star billing in the title. After the Overture, it is Judas whom we hear singing "Heaven on Their Minds," reflecting back over his time spent with Christ. He sees that Jesus has become deluded, changing from a simple teacher of good living to—well, this line expresses it well, "You've begun to matter more than the things you say." The song ends with the charge that the disciples are blind with "too much heaven on their minds," that "it's all gone sour."

In Jerusalem, the priests look down on Jesus (just before the crowd sings the song "Hosanna") from some kind of scaffolding. Alarmed at the large crowd welcoming him to the city, some of them sing, "he is dangerous," and he is "the top of the poll" (the latter one of many anachronistic elements in this movie that have surprised and delighted audiences). Caiaphas worries that the crowd will get out of control and bring down the wrath of the Romans on them all, so he proposes that "this Jesus must die," and they all take up the declaration. Thus, there is no question that Jesus is killed because he threatens the status quo, and in the following events Pilate is shown as easily manipulated by the priests because they know that he is afraid of falling into disfavor with Rome.

"Hosanna" and "Simon Zealotes/Poor Jerusalem" scenes/songs are especially insightful. The crowds shout their approval of Jesus, "Hey JC, JC you're alright by me," as Caiaphas tells Jesus to tell them to stop. Jesus responds that this would be wasting his breath, and the crowd keeps up their shouts of support. However, this time they say, "Hey JC, JC won't you fight for me?" Note the pained expression on Jesus' face at this point. Then, Simon Zealotes

dances before Jesus and urges him to lead the fight now that he is as strong as "the filth from Rome who rape our country." If he will just "add a touch of hate at Rome," he will get "the power and the glory." Then, echoing the Gospel account of Jesus' weeping over Jerusalem, Jesus replies that neither he, the Romans, "nor doomed Jerusalem itself," really understand these concepts. At the point when Jesus sings, "To conquer death you only have to die," he is the spiritual master of the scene, the only one to really understand that as Messiah he must submit to death. This is probably as close to the Jesus of the four Gospels as this film ever gets.

The Gethsemane scene is matched in its spiritual agony only by the *The Miracle Maker* scene. Jesus is struggling and pleading with God until he seems to be driven into a corner and gives in to divine will, saying that he will drink the cup of poison. He sings, "Bleed me, beat me, kill me take me now—before I change my mind."

The death of Judas, protesting that he has "been saddled" with the murder of Christ, is especially moving when, to the tune and words of "I Don't Know How to Love Him" (Mary Magdalene's song), Judas expresses his puzzlement over why "you chose me for your crime." This ends with his accusation that it is Christ who has murdered him.

The scenes of the trial before Pilate, the 39 lashes, and the crucifixion itself flow quickly by to the accompaniment of sometimes frenzied music. Judas, singing from some point beyond the grave, sings the title song "Superstar" between the 39 lashes and "The Crucifixion." Six of the traditional "last words of

Christ" are included, then the quiet orchestral piece "John Nineteen Forty-One."

There is no resurrection scene, which should be no surprise in that neither Tim Rice nor Andrew Lloyd Webber belonged to a church. In interviews at the time they stated that they chose the story of Jesus because of its powerful drama—and they intended to leave the question of resurrection up to the audience. The quiet, meditative conclusion could be heard as either a sun-setting or a sun-rising tune. Many listeners initially were puzzled by the title, until it was pointed out that the title is a reference to St. John's Gospel: *"Now there was a garden in the place where he was crucified, and in the garden there was a new tomb in which no one had ever been laid."*

For Reflection/Discussion

1. Many Americans know the songs in *Jesus Christ Superstar*, but have never seen this movie. If that's your experience, then you might start by comparing your memories of these songs with the way Jewison put them on film. Did some scenes surprise you? Disappoint you? Inspire you?

2. You may have participants in your group who "grew up with" *Jesus Christ Superstar* as a cultural milestone and their attitudes toward it may have changed over time. Can you remember when you first heard these songs? Is the production still relevant? Does it raise new ideas today?

3. Discuss the film's central figures. Who would you describe as the central figures in this film? What do you think of these depictions of Judas, Mary Magdalene and Jesus? In this case, you could also ask how each of the central figures views the others based on what we learn through the songs and the

scenes in the film. Do these figures ever understand each other?

4. If you are viewing the movies in this book as a series, compare these portrayals to those in other films, especially Judas and Mary Magdalene. For example, this Mary Magdalene follows a centuries-old assumption that she had been a prostitute—a detail disputed by many contemporary scholars. In a series, these questions will become richer with perspectives from each new film.

5. Talk about the songs. What seems to be the conflict between Jesus and the disciples in "What's the Buzz"? When the rock opera debuted, followed by the movie, many people were uncomfortable with emotions expressed by Mary Magdalene in "I Don't Know How to Love Him." How do you respond to Mary's song today? And, what does the song "Could We Start Again, Please?" contribute to the story, especially inserted between "Herod's Song" and "Judas' Death"?

6. Could the "Simon Zealotes" scene be regarded as another temptation scene? Check out Matthew 4:1-11 and Luke 4:1-13.

7. Compare "Poor Jerusalem" to the accounts of Jesus mourning over Jerusalem—Matthew 23:37-39 and Luke 13:34-35. How does this show that Jesus intends to follow a very different vision of his ministry than the popular one?

8. What do you think of the depiction of Jesus becoming overwhelmed by the crowds pressing him with their needs?

9. How does the depiction of Jesus and the disciples at the Last Supper deviate from the traditional paintings? Does he seem to be in control, or going "with the flow"? What about the way in which he and

Judas part? Compare this sequence with paintings or with scenes in the other films in this series. In what state are the disciples shown while Jesus and Judas are arguing, and are they singing about? How is their ambition at this moment similar to what James and John asked for in Mark 10:35-45?

10. The rock opera and the film take creative liberties with Jesus' arrest, trial and crucifixion. Some of the lines in these scenes are startling, even bitterly funny. You'll have a lively discussion comparing some of these scenes with the Gospel accounts!

11. How do you respond to the way the movie ends? Note that in the concert version, following the frenetic music of "The Crucifixion," we hear just the quiet music entitled "John Nineteen Forty-One." But in the film we see the last shot, in which the cross is silhouetted against the orb of the sun, and then a shepherd slowly leads his sheep across the screen, accompanied by the soft music. If you believe in the Resurrection, would you interpret this as a setting or a rising sun? Why might a nonbeliever interpret this as a setting sun?

Jesus Of Montreal (1989)

MPAA rating

R

Ed's Content ratings (0-10)

Violence **4**

Language **1**

Sex **5**/Nudity **2**

Running time

2 hours

Director

Denys Arcand

Major Characters/Cast

Daniel: Lothaire Bluteau

Father Leclerc: Gilles Pelletier

Mireille: Catherine Wilkening

Constance: Johanne-Marie Tremblay

Martin: Rémy Girard

René: Robert Lepage

Again, the devil took him to a very high mountain

*and showed him all the kingdoms of the world and
their splendor; and he said to him, 'All these I will
give you, if you will fall down and worship me.'
Jesus said to him, 'Away with you, Satan! for it is
written,*
*"Worship the Lord your God,
and serve only him."'*

—*Matthew 4:8-10*

*Woe to you, scribes and Pharisees, hypocrites! For
you clean the outside of the cup and of the plate,
but inside they are full of greed and self-indulgence.*

—*Matthew 23:25*

*Then they came to Jerusalem. And he entered the
temple and began to drive out those who were sell-
ing and those who were buying in the temple, and
he overturned the tables of the money changers and
the seats of those who sold doves; and he would not
allow anyone to carry anything through the tem-
ple. He was teaching and saying, 'Is it not written,
"My house shall be called a house of prayer for all
the nations"?
But you have made it a den of robbers.'*

—*Mark 11:15-17*

Key Scene: Discovering the Scholars' Jesus

*Scene: "Looking for Jesus." Start at 11:09. Stop at
13:46.*

A theology professor is talking with Daniel about
new discoveries being made about the origins of
Jesus and Christianity. As they enter a parking garage,
he hands the actor some articles he has photocopied
and tells him not to reveal to anyone where they
came from because it could get him in trouble. At

a library, Daniel is looking at sketches of a man crucified on a Tau cross, rather than the traditional T-shaped one. A librarian brings him some books and assures him that Jesus is looking for him.

The Film

French-Canadian director Denys Arcand's film, despite its subtitles, has attracted a devoted following. For two years, it was the hit of the Dayton Lenten Film Series, drawing our largest audiences—well over 250. It is a thinking person's version of the Christ story. Arcand transports the original Jesus story to his own city. He also is taking into account the results of biblical studies over the past two centuries.

The story is a simple one. Father Le Clerc, a priest in charge of a Montreal shrine, wants to improve a tired script for a Passion play so that crowds will return again. He hires Daniel, an earnest young actor/director, who agrees that the insipid, sentimental play needs all the help it can get. Throwing himself into reading all the scholarly studies of the historical Jesus that he can find, Daniel throws out the old script and writes a new one based on his research. His Jesus is an iconoclastic prophet set against the crass commercialism and dehumanizing forces of the city and church.

Daniel also starts a search for other actors to play opposite his Jesus. His quest takes him into some strange places, such as a studio where actors are dubbing the soundtrack of a pornographic film and a TV studio where the acting talent of a beautiful young woman is being wasted on an ad extolling the virtues of a cosmetic.

Once the cast is assembled, they enter into their characters and find their lives affected in surprising

ways. The new Passion play is a hit with its first audience with Jesus being portrayed in a way that most have never seen before. Young Daniel becomes the talk of the town, at least among the intelligentsia. But Father Le Clerc is dismayed at the portrayal of Jesus as an iconoclastic figure, far too down-to-earth for his taste. He calls in his superiors to view the play and back him in his decision to shut it down. The scene in which Daniel/Jesus condemns the Scribes and the Pharisees is played out with the Catholic priests looking down upon him from some steps. Daniel's discovery that Father Le Clerc is having an affair with Constance adds force to his on-stage denunciation of the priests and Pharisees!

The conflict between the clerics and Daniel leads to tragic results, and yet out of tragedy comes an unusual form of life-giving resurrection. *Jesus of Montreal* is more than a retelling of the ancient story; it is a reinterpretation of the old Gospel story for those who are satisfied neither with the traditional church nor with the shallow values of contemporary society. A deeply moving film with a very unusual form of "resurrection," it is the only one among these 12 films to pointedly explore the findings and implications of modern biblical studies.

Caution: The funny scene in which Daniel is looking for a "disciple" in a studio where a porno film is being dubbed includes swearing and brief sexual material, so forewarn viewers and be wary of using this with youth, unless parents are alerted.

For Reflection/Discussion

1. This is a film that critiques modern culture and media, so begin by discussing how Arcand chose to present his scenes as a filmmaker. Which scene

stands out in your memory? What contributed to the scene's effectiveness: the acting, the camera work, the editing, the lighting, the music or sound effects?

2. Discuss the original version of a Passion play in this film. Does the problem in the film seem familiar to you? What is your experience with pageants and plays in churches? Some congregations have terrific theatrical programs; in others, pageants and plays become an annual ordeal. Is there a larger relationship between worship and theatrical production? This might be an occasion to bring in clergy or a church's musical director or a Christian educator to talk about these issues.

3. In the movie, how does Daniel's research affect him? Have you had such an experience, perhaps when taking a course about the Bible in college? How could critical studies of the Gospels refresh or change our view of Jesus?

4. Were you disturbed or amused at the places and circumstances of Daniel's search for fellow actors? Can you describe parallels between this part of the film and the Gospels' accounts of the origins of Jesus' followers.

5. Were you surprised by the priest's reaction to Daniel and the revised play? Are there parallel Bible stories about such conflicts?

6. Were you surprised that the priest had a sexual relationship with Constance? How is he depicted as both a weak and a strong character throughout the movie?

7. Talk about the temptation scene. Do you think this is an effective way to present it in a modern city? Is there evil in the agent's offer? Compare this to the line in the title song of *Jesus Christ Superstar*: "If

you'd come today you would have reached a whole nation. Israel in 4 BC had no mass communication ... "

8. What were your feelings as a result of the "crucifixion"? Could there have been any other resolution of the conflict? Any irony in the ways that the two hospitals received Daniel?

9. What do you think of the filmmaker's version of "resurrection"? How is this a humanistic view of the Resurrection? Do you think Christianity would have survived those tough first centuries if this were the belief of the apostles?

10. How might this provide comfort or support for Daniel's disciples/fellow actors?

11. Who remains faithful, and who "sells out"?

12. What do you make of the subway singers that we see at the beginning and end of the film?

PART 3

"Christ Figure" Films

CHAPTER 9

Cool Hand Luke (1967)

MPAA rating

Not rated

Ed's Content ratings (0-10)

Violence **4**

Language **2**

Sex **4**/Nudity **1**

Running time

2 hours, 6 minutes

Director

Stuart Rosenberg

Major Characters/Cast

Lucas "Luke" Jackson: Paul Newman

Dragline: George Kennedy

Captain: Strother Martin

Arletta Jackson: Jo Van Fleet

Boss Godfrey: Morgan Woodward

Tramp: Harry Dean Stanton

Society Red: J.D. Cannon

Alibi: Ralph Waite

Gambler: Wayne Rogers

Koko: Lou Antonio

Babalugats: Dennis Hopper

The Girl: Joy Harmon

To you, O Lord, I call; my rock, do not refuse to hear me, for if you are silent to me, I shall be like those who go down to the Pit. Hear the voice of my supplication, as I cry to you for help, as I lift my hands toward your most holy sanctuary.

—*Psalm 28:2*

My God, my God, why have you forsaken me?

—*Psalm 122:1*

He said, 'Abba, Father, for you all things are possible; remove this cup from me; yet not what I want, but what you want.'

—*Mark 14:36*

Key Scene: The Silence of God

Scene: No. 33 "Questions From a Hard Case." Time: 1:56:39—1:59:36. Stop at at sound of a car driving up. To catch a moment of humor, continue to 2:00:09.

Luke, an escaped prisoner, enters an old, weather-beaten church. It is dark and deserted. He looks around and settles in, sitting down on one of the benches. Now he has time to think. He muses aloud, addressing God in his usual semi-mocking manner. Luke says that it has been a long time since "you and me had a talk." He pauses, then says OK, and assumes the traditional posture of prayer by kneeling, folding his hands, and closing his eyes. No response. Luke opens one eye and looks upward. From his

point of view we see empty rafters. Still no answer. Another shot of empty, silent rafters. Luke confesses that he has been a pretty "hard case, but you must admit," he tells God, "you haven't dealt me much of a hand." No answer. At one point, an overhead shot shows Luke looking up. He sighs and then stands up, exclaiming: "I guess I'll have to find my own way." If you continue for a little more than 30 seconds, Dragline appears, calling softly to him, "Luke, Luke." Luke looks up to the rafters and says, "Is that your answer, Ole Man? I guess you're a hard case, too."

Note: This film scene is parallel to the New Testament's Garden of Gethsemane Prayer. The next three scenes also parallel The Betrayal, followed by The Crucifixion and then a version of Easter.

The Film

Many movie fans consider this the best prison movie ever made. For our purposes, it is one of the best "Christ Figure" films ever made.

If you plan to show these films in a chuch group, you may encounter some skeptics. To many churchgoers, the phrase Christ Figure invokes an image of a noble person willing to sacrifice himself for others—someone like Atticus Finch in *To Kill a Mockingbird.*

In director Stuart Rosenberg's classic *Cool Hand Luke*, we meet an anti-hero—one of the most famous in a wave of anti-heroes who swept through Hollywood in the late 1950s and the rebellious 1960s. Luke is a Christ figure in the sense that he is anti-status quo. He stirs up opposition from those benefiting from the way things are. He has a charismatic effect on others, thus attracting followers,

and he pays for his rebellious independence with his life.

This is a powerful story of spiritual liberation and the birth of a myth. Lukas Jackson, dubbed "Cool Hand Luke" by fellow prisoner Dragline when Jackson coolly bluffs his way to victory in a card game, is at the center of the myth and an agent of liberation. Once a decorated war hero, he drifted aimlessly through life until being imprisoned for a drunken prank. Luke is as unable to fit into the rigid rules of the Southern prison camp as he was in the outside civilian world. The warden and guards mark him from his first day as a troublemaker. This he proves to be once he earns the trust and respect of the prisoners. Luke fears nothing, facing all obstacles with what Dragline calls "that Cool Hand Luke smile," a mixture of disdain and mockery based on superior knowledge.

Luke sneers at the rules. He challenges his fellow convicts' fear of a lightning-bolt-wielding God by standing out in a thunderstorm and daring the Old Man to strike him dead for his impiety. The other prisoners cower in fear in the back of the truck and expect to see Luke struck down at any minute. In another scene, he leads the men in a conspiracy to subvert the power of the guards by working twice as fast as they were supposed to on a road-paving job, thus upsetting the schedule. He runs away twice. After the first attempt, according to the rules, he is shut up in the infamous "box." The guards attempt to break him in various ways. Eventually, Luke is forced into a brutal ordeal of digging and filling in holes in the prison yard, a Sisyphus-like process designed to break his spirit. The guards promise that they will kill him if he tries to escape again. He does, this time

Dragline also jumping into the dump truck Luke has stolen. When the guards rush to their cars, they find that Luke has disabled all the motors. Miles down the road, Luke decides it would be better if he and his friend split up.

Luke has always felt he has had to go at it alone. The closest we see him engaged in a religious act is when he sings a half-mocking song "Good Ole Plastic Jesus." That song is a way of working through his grief after he hears of his mother's death.

Luke is aware that he is perceived by the other prisoners as a Christ figure, though he doesn't want this role and would never use such a term. He is an unwilling Christ figure, an anti-hero. He cries out at one point to the inmates, "Stop feeding on me!" Just the opposite of John 6:50-56!

However, he will not be let alone. The prisoners need someone to free them from their fears, and the guards need to kill him because his inability (as much as refusal) to fit in threatens their power. The final church scene, then, is Luke's Gethsemane. He prays for enlightenment, but nothing comes other than the familiar face of dimwitted Dragline. God neither talks with nor sends angels to minister to Luke. He feels utterly abandoned, and this too can be compared to Jesus' feeling of abandonment when, on the cross, he cries out the first lines of Psalm 122, *"My God, my God, why have you forsaken me?"*

Luke knows his fate. When Dragline appears and naively says that things will be the same again if only Luke will surrender, Luke says sarcastically, "I'll bet they'll even give us our old bunks back!" Part of the burden of being a Christ figure is to know one's fate, even if one experiences the silence of God. It is not

so much that God is silent as it is that he "speaks" in ways we cannot, or do not want to, hear. Luke is right, Dragline is God's answer to his prayers, and God is indeed "a hard case."

Even in his death, Luke is the rebel. He goes to the window and mocks the Captain when he calls out, "What we have here is failure to communicate." Immediately, Luke is shot. This deliberate act of murder sets Dragline free from his illusions about, and his fear of, the guards. He rushes from the church and grapples with the killer, knocking the guard's mirrored sunglasses off. Their fate symbolically shows Luke's impact on the men. The film even has what I call a "Little Easter" scene in which the myth of Lukas "Cool Hand Luke" Jackson is born. Dragline tells the eagerly listening men about Luke, the group resting from weed chopping and the little church directly across the road from them. He paints the story of "a world shaker," declaring, "Hell, they wasn't gonna beat him." Thanks to "Cool Hand Luke," Dragline is a bit wiser and neither fears nor respects the guards and their rules. The camera, mounted on a helicopter, summarizes Luke's role in an unforgettable shot that shows the iconic photo of Luke and two women superimposed over the cross-like intersection of two roads.

For Reflection/Discussion

1. This film is a good opportunity to talk about the powerful experience of "the silence of God" or "the dark night of the soul," which runs through many centuries of Christian experience. You might want to find clippings concerning Mother Teresa's honest description of her own experience of God's silence over many years. Of course, many other Christian

classics explore this challenging issue. Ask your group: Do you regularly hear God in prayer? Do you experience periods of silence? Talking about Luke's experiences in the film can surface lots of honest conversation about our own spiritual lives.

2. Discuss the crime that touched off this whole drama. Why did Luke commit this crime? What do the Captain and the guards think about it? You might want to discuss America's huge prison population and whether or not we have a fair system for determining who should be imprisoned. Or, you might want to discuss parallels with the Gospel stories. Some Bible scholars argue that the crime that eventually led to Jesus' death was his disturbance of commerce in the temple area, sometimes called "casting out the money changers" or "cleansing the temple." Jesus was attacking the very basis of the scribal and priestly power structure, so if they were to survive, they had to remove him. However, being under Roman occupation, they did not have the authority to administer the death penalty. They needed to persuade Governor Pilate to actually carry out Jesus' execution. Thus the penalty that was carried out was not a Jewish one, death by stoning, but a Roman one, death by crucifixion. Is there any parallel between Luke's crime and scenes of Jesus disturbing temple merchants in other films?

3. What are the Captain's biggest concerns about the rules? What does Luke seem to think of the rules? How do most of the prisoners deal with the rules? Do you see any similarity between Luke's attitude in this film and the struggles of the apostle Paul as the early Christian church emerged in the New Testament? Or, do you see parallels with Jesus' own response to people accused of breaking the rules?

4. Look again at the boxing match between Luke and Dragline. Compare this with a typical Hollywood action movie. Were you surprised that Luke did not win? Did Dragline really win? Talk about the change in the crowd's mood. What was it about Luke that won their grudging admiration? How do you respond to Luke's actions in this sequence?

5. Reread Jesus' Sermon on the Mount, especially Matthew 5:38-42 containing the famous "second-mile" passage. Discuss this movie in light of these passages. Talk about the scene in which the prisoners work so fast that they confound their guards.

6. Discuss ways that Luke illustrates themes from the life of Jesus. For example, the prisoners fear an angry God. Should Luke's defiant response to the thunderstorm be considered sacrilegeous or inspirational?

7. How do the prisoners change from hostility to adulation for Luke? Are there parallels between this process and Jesus forming and working with his circle of followers?

8. When Luke runs away and sends a picture to Dragline, how is this like a religious icon to the prisoners? Why does Dragline tear up the photo later?

9. Luke courageously and often surprisingly confronts the inevitable outcomes of his actions at various points in the movie. Remember Jesus' words, "Nevertheless, not my will, but yours be done." Have there been times in your life when that has applied? What did you do next? What happened?

10. What do you think of the Little Easter scene at the end? How is Dragline different now? Why do you think that the "crosses" were included in the

super-imposed picture during the arial shot? What has happened over the centuries to those who have challenged the status quo or "bucked the system"?

Here's a fun story for you: I had the chance to speak with the director of the film, Stuart Rosenberg, in the early 90s. He told me that, along with the Christ Figure motif, he also used the Myth of Sisyphus in the film—which underlies the sequence in which Luke is forced by the guards to dig and fill in the holes day and night. Rosenberg had long been fascinated by the ancient myth as retold by French existentialist Albert Camus. He imagined that Sisyphus had come to accept his rock rolling as his purpose in life and that he was always smiling while pushing the rock uphill, even as he went back down to resume his work. He therefore showed Luke smiling during all of his ordeals, which we see in the montage sequence during Dragline's Easter-like recital.

Bagdad Café (1987)

MPAA Rating

PG

Ed's Content ratings (0-10)

Violence **1**

Language **1**

Sex/Nudity **3**

Running time

1 hour, 35 minutes

Director

Percy Adlon

Major Characters/Cast

Jasmin: Marianne Sägebrecht

Brenda: CCH Pounder

Rudi Cox: Jack Palance

Phyllis: Monica Calhoun

Salomo: Darron Flagg

Cahuenga: George Aguilar

Sal Sr.: G. Smokey Campbell

Debby: Christine Kaufmann

Sheriff Arnie: Apesanahkwat

Münchgstettner (husband): Hans Stadlbauer

For she grew up before him like a young plant,
and like a root out of dry ground;
she had no form or majesty that we should look
at her, nothing in her appearance that we should
desire her.

—*Isaiah 53:2 (gender changed for film)*

A soft answer turns away wrath,
but a harsh word stirs up anger.

—*Proverbs 15:1*

Blessed are the poor in spirit, for theirs is the
 kingdom of heaven.
Blessed are those who mourn, for they will be
 comforted.
Blessed are the meek, for they will inherit the earth.
Blessed are those who hunger and thirst for
 righteousness, for they will be filled.
Blessed are the merciful, for they will receive mercy.
Blessed are the pure in heart, for they will see God.
Blessed are the peacemakers, for they will be called
 children of God.
Blessed are those who are persecuted for
 righteousness' sake, for theirs is the kingdom of
 heaven.
Blessed are you when people revile you and
 persecute you and utter all kinds of evil against
 you falsely on my account.

—*Matthew 5:1-11*

Then people will come from east and west, from
north and south, and will eat in the kingdom of
God.

—*Luke 13:29*

Key Scene: Off to a Bad Start

Scene: No. 4 "This Ain't No Grand Hotel." Time: 0:16:45 to 0:26:33, voice cue, "put this baby in the pot..."

The African American Brenda, owner of the Bagdad Café and Motel, has had a bad day. Her shiftless husband, Sal, back from town, has forgotten to take care of their broken coffee urn; her son, Salomo, does nothing but play his piano; and few customers stop in for gas, food, or a room. The camera shows her slouching in an outdoor chair. Then, Jasmin shows up pulling her large suitcase with no car in sight. Brenda is suspicious and reluctant to rent her a room. Jasmin is equally unimpressed with the unkempt Brenda, imagining her as a cannibal cooking her in a big pot. What Brenda does not know is that she and her husband are tourists who have had such a serious falling out that she has taken her suitcase and walked away from her loutish husband. She is very much on her own, but by no means the criminal that Brenda has conjured up in her suspicious mind.

The Film

This wonderful little "Christ Figure" film of grace grew out of a trip that Percy Adlon and his wife, Elenore, made to America. Natives of what was then West Germany, the filmmaking duo were struck by a café they stopped at in the Mojave Desert. Known as The Sidewinder Café, the place and its interesting characters called forth a story. This became their first English language film. Although there was no big studio campaign to promote it, the small film received praise from the critics and steadily gained popularity over the years. Adults and mature youth

will find much to enjoy and discuss. At 95 minutes, its relatively short length makes it suitable for various kinds of gatherings or events.

Jasmin is a large-figured German housewife fed up with her boorish husband during their tour of the U.S. During a rest stop on their journey, she takes her return airline ticket and a suitcase from their rented car and sets off down the highway in the middle of the Mojave Desert. After leaving their large coffee thermos by the road, the husband drives away. An old pickup truck driven by Sal, a black man, stops and picks up the coffee urn and offers Jasmin a ride. She refuses. We soon know that the mysterious foreigner is someone special, because as she looks up at two beautiful lights in the sky, the camera shows us Jasmin with the lights on either side of her, creating a halo-like impression.

That's not the first impression at the Bagdad Café! Brenda, Sal's take-charge wife, sees nothing heavenly in Jasmin when the tired and dusty tourist trudges up to the motel to ask for a room. Brenda has chewed out both husband Sal for forgetting to bring back an electric coffee maker from the repair shop and their son for continually playing his electric piano. Brenda receives little help from the men, and, in her anger and frustration, she drives her husband away. Thus, she is in no mood to be civil to a traveler who arrives with no car and who speaks with a foreign accent.

What happens as a result of the mysterious guest should happen to us all—grace descends upon the seedy motel/café like magic, transforming all of the lives in this tiny community. This overweight hausfrau becomes one of the most charming and engaging Christ figures to be found

in film—reminding us again that grace can flow through unusual persons in unlikely settings. She transforms the embittered Brenda into a gracious hostess whose inward beauty is reflected in her outward transformation from slovenly figure to well-groomed woman. Brenda's son, Salamo, is freed from his mother's oppression to become the talented musician he is meant to be. Jasmin's relationship with resident artist Rudi is fun to watch, with a delightful twist at the end that pays tribute to sisterhood.

The symbolic Good Friday that threatens to end the friendship of Jasmin and Brenda gives way to one of Easter, with Jasmin decked out in a gleaming white dress. And the merry scene of food and magic in the Bagdad Café can be seen as a foretaste of the Messianic banquet foretold by Christ.

For Reflection/Discussion

1. It's easy to jump into discussions of "the meaning" of this film, but consider starting a conversation about this movie with your emotional responses. Remember, I suggested this first step after watching Mel Gibson's movie. This time, the emotional responses will be very different! In this case, ask questions like: Which scene touched you most? Which scene are you most likely to remember tomorrow? Which scene inspired you? Or, surprised you? In asking this kind of question, you are responding to the power of this little movie to touch our lives in a memorable way—just as Jesus continues to touch us on an emotional level. Give each participant a chance to say a few words.

2. Talk about the relationships in this movie. Among adults, you'll touch off a lively discussion about the daily challenges we face in our relationships. How

do Jasmin's actions disturb and transform these relationships? For example, when Brenda verbally attacks Jasmin for spending time with her kids, how is her refusal to retaliate in kind a "Gandhian" response? For Scriptural reference, see Proverbs 15:1.

3. Part of the fun in watching Christ Figure films is talking with friends about parallels between the movie sequences and Jesus' life. There are no right or wrong answers here, and you are likely to find participants bringing up a long list of connections they see in the movie. You might write these ideas on a large pad of paper to spark further ideas. Quite a list will form after watching this movie. Depending on which connections your group identifies, ask paticipants to pull out their Bibles and find the relevant Gospel passages. Read some of the short ones aloud. Do they fit? Or did this movie add a twist to what we find in the New Testament? What did *Bagdad Café* show you that might give you a new perspective on these Bible passages?

4. Many objects in the movie take on symbolic meaning. List some of them and ask participants to describe their roles in the movie, including: the coffee thermos, lights in the sky, the electric piano, Lederhosen, the boomerang and the box of magic tricks. When you watch the movie, you'll see other objects you might want to add to this list.

5. Most of Percy Adlon's films are not well known in the U.S., but he was born in 1935 in Munich and began making movies in the 1970s. He has received international acclaim for several of his films, so *Bagdad Café* is a good choice if your group wants to discuss the the filmmaker's art in telling a story. Did you notice anything surprising about camera angles

or the editing of scenes in this movie? How did you respond to the soundtrack (which ranges from music to silence or natural sound effects)? Did you find any striking visual images in this movie that you'll remember for a long time?

6. Compare Brenda and Jasmin—two fascinating characters! You might start by asking: What does Brenda think of her new customer? What does Jasmin think of Brenda? Participants will keep the questions and answers flowing: Which of the two women do you identify with? Why does their relationship change? How does Jasmin's physical place in the café change as her relationship to Brenda and the others improves? What physical changes in the two women do you observe as the film progresses? What can we learn about the difficult challenge of forming cross-cultural friendships today?

7. How do the changes in Rudi's portraits reflect the changes going on in Jasmin, Brenda, and in the café— especially the last one with the rainbow over its subject?

8. The café becomes an oasis, even an Eden, in the middle of the desert, but there is trouble in paradise: What happens just as everything is going so well? Could this be considered a type of "crucifixion"? Is Jasmin's forced absence from the café a form of death? What does the trucker mean when he peeks in and says, "The magic's gone"?

9. Where do you see moments of grace in the film? How is Jasmin's effect upon the other characters similar to that of Christ's upon the people whom he encountered? But, who is the one character that is not changed by Jasmine? What does she do, and what

is the meaning of her last words, "Too much magic around here"?

10. Listen carefully to the theme song and ask: How is Jasmin "called" as an instrument or channel of grace? Find a copy of the "Prayer of St. Francis" online (Wikipedia has the prayer along with an overview of its history) and use it to close the group.

CHAPTER 11

Broadway Danny Rose (1984)

MPAA rating

PG

Ed's Content ratings (0-10)

Violence **1**

Language **1**

Sex/Nudity **2**

Length

1 hour, 24 minutes

Director

Woody Allen

Major Characters/ Cast

Danny Rose: Woody Allen

Tina Vitale: Mia Farrow

Lou Canova: Nick Apollo Forte

Ray Webb: Craig Vandenburgh

Barney Dunn: Herb Reynolds

Vito Rispoli: Paul Greco

Angelina: Olga Barbato

Rocco: Tony Turca

Teresa: Sandy Richman
Joe Rispoli: Frank Renzulli
Vito Rispoli: Paul Greco
Johnny Rispoli: Edwin Bordo
Johnny's mother: Gina DeAngeles
Sid Bacharach: Gerald Schoenfeld
Also: Sandy Baron, Corbett Monica, Jackie
Gayle, Morty Gunty, Will Jordan, Milton Berle (as
themselves)

*... he had no form or majesty that we should look
at him,
nothing in his appearance that we should desire
him.*

—*Isaiah 53:2b*

*When the Pharisees saw this, they said to his
disciples, 'Why does your teacher eat with tax
collectors and sinners?'*

—*Matthew 9:11*

*Love is patient; love is kind; love is not envious or
boastful or arrogant or rude. It does not insist on
its own way; it is not irritable or resentful ...*

—*1 Corinthians 13:4-5*

*Then people will come from east and west, from
north and south, and will eat in the kingdom of
God.*

—*Luke 13:29*

Key Scene: A Loser With a Winning Philosophy

*Scene: Ch. 10 "Living Like a Loser" Time: 0:48:02.
Stop at 0:52:30.*

Danny and Tina are on the run from gangsters. Intending to go into hiding, they stop by his apartment so he can pack a few personal things. Unimpressed with his untidy lodgings, Tina says it looks like a dump and that he is a loser. Danny disagrees. As they talk, he learns of her old ambition of being an interior designer (though we learn she has no real taste for good design—nor does Danny, for that matter). As he has supported his small-talent clients, he encourages her, even when she says it is too late for her. They also share philosophies of life, hers amounting to: "Grab all you can, while you can." Danny sums his up in three words, passed on to him by his uncle Sidney: "Acceptance, forgiveness and love."

The Film

This movie earned two Oscar nominations (for direction and screenplay), but it seems all but forgotten three decades after its release. Even Woody Allen fans flock first to his other big hits. But, over the years, I have discovered something about *Broadway Danny Rose*: Even people who claim to "hate Woody Allen films" tend to enjoy this one! It is so funny and charming that people find themselves enjoying the movie despite their attitudes toward Allen's personal life and his other work.

Broadway Danny Rose is the story of a down-on-his-heels Broadway talent agent that presents us with a very intriguing bespectacled Christ figure and a cruciform lifestyle.

Danny Rose handles the acts that no one else will touch—a tap dancer with a wooden leg, a one-armed juggler, a balloon folder. He helps them in every aspect of their performance and even becomes

involved in their personal lives. Occasionally, when Danny finds a performer with real talent and helps him perfect an act, that entertainer leaves Danny for the services of a more upscale agent. Once the act has become a success, the perfomer no longer even wants to acknowledge Danny's role in his career.

In the film, we wonder: Will this happen again with Lou, the singer whom Danny has rescued from his alcoholism and is now beginning to attract attention?

When Danny manages to convince Milton Berle (playing himself) to come by the club where Lou is singing, it appears to be Lou's big break. As the film tells the story, Berle's TV variety show holds the potential to make Lou a real star.

The night of Berle's visit is so important that Lou complicates things by insisting that his girlfriend Tina (played by Mia Farrow) be in the audience. The problem: Lou is a married man and can't be seen in public with Tina, and Tina is the widow of a slain mobster. This is a madcap comedy and Lou, Tina and Danny become entangled in a complex series of relationships. At one point, mobsters are trying to rub out Danny. Events quickly swirl to a comic pace. The comedy is so well developed that I have shown this film to teenagers who love it as much as adults.

The ensuing incidents involve what could be described as a Last Supper, a type of "crucifixion" and a reconciliation that acts as a sort of secular "Easter" moment. Mia Farrow is wonderful in the brash, abrasive role of Tina. I consider *Broadway Danny Rose* to be a great visual parable!

For Reflection/Discussion

1. Start with the gathering of comedians, which wraps around the story like bookends. What is

the purpose of these scenes? How does this evoke storytelling as an important part of our community and our traditions? Who are the storytellers in your community? Is there any circle like this one in your community?

2. What do you think of Danny's clients? They are outlandish, of course! But then ask: Are there any parallels between Danny's choices and Jesus' choices of his 12 followers and the people Jesus welcomed throughout his public ministry?

3. Read 1 Corinthians 13:4-7, where St. Paul lists the qualities of love: *"patience; kindness ... bears all things, believes all things, hopes all things, endures all things."* Where do you see this in Danny's relationships? Especially in his dealings with Lou!

4. Compare Tina's philosophy of life with Danny's. Is this a spectrum of perspectives on life that you recognize among people you know? Where do you find yourself on this spectrum? What influences pull us toward either end of the spectrum?

5. This film is a good opportunity to talk about a topic that rarely comes up in congregations these days: guilt. In the movie, we hear a range of viewpoints. In commenting on his clients who leave him, Danny says that they felt no guilt. Danny says, "It's important to feel guilty. Otherwise ... you're capable of terrible things." But, Tina denies ever feeling guilty, saying, "I just think, you gotta do what you gotta do, you know? Life is short. You don't get any medals for being a Boy Scout." You could raise questions like: On balance, is guilt a good thing? A bad thing? What do you think the Bible teaches us about guilt and regret? What does Jesus teach? These are major themes that span the Bible and you may find

participants pointing to a range of biblical passages. Consider putting up several newsprint pads and grouping some of the Bible stories that involve guilt and regret.

6. Talk about Danny's conversation with Tina, when he argues that it's important to have some laughs, "but you got to suffer a little, too. Because otherwise, you miss the whole point of life." Read Jesus' words in Mark 8:34 or Paul's statement in Romans 5:3-5. What parallels do you find here?

7. As with all of these Christ Figure films, there are many opportunities to compare dialogue or other details in the movie with elements in the life of Jesus. The most obvious is Danny's advice that life should be about "acceptance, forgiveness and love." How does this compare with the overall message of Jesus? Or, the message of Paul?

8. How is Lou's treatment of Danny after the successful Waldorf show like a crucifixion? And Tina's role? How must Lou's words hurt, "That's your trouble, Danny. You make everything into a personal situation." Isn't this the theme of Danny's life?

9. How is the Thanksgiving dinner gathering at Danny's apartment like a sacramental meal?

10. Were you surprised at what Danny did when Tina arrived at his door? What did the sequence of her and Lou reveal about what was going on in her mind, despite her earlier disdain for Danny's observation about guilt? How is that final wordless scene on the sidewalk an Easter scene?

Babette's Feast (1987)

(French and Danish with English subtitles)

MPAA rating

PG

Content ratings (1-10)

Violence **0**

Language **0**

Sex/Nudity **1**

Running time

1 hour, 42 minutes

Director

Gabriel Axel

Major Characters/Cast

Babette Hersant: Stéphane Audran

Filippa: Bodil Kjer

Martine: Birgitte Federspiel

Achille Papin: Jean-Philippe Lafont

General Lorens Löwenhielm: Jarl Kulle

Steadfast love and faithfulness will meet;

righteousness and peace will kiss each other.

— **Psalm 85:10**

So, whether you eat or drink, or whatever you do,
do all to the glory of God.

—**1 Corinthians 10:31**

Key Scene: When a Meal is Like Communion

Scene: No. 14 "Dinner Is Served" Time: 1:11:11.
Because scene 14 is over 20 minutes long, you can fast
forward to 1:20:00. Stop at 1:29:50. (End visual cue—
the lady who thinks the wine is lemonade is smiling
now, and reaches for another glass of wine.) This can
be done beforehand and the player put in "Pause."
However, if there is time, do the fast forwarding while
the group is watching, and they will see more of the
context of the group sitting down and eating and
talking about the Pastor.

The camera cuts back and forth between Babette
and the coachman in the kitchen and Erik serving
the group delicious meals and pouring wine. The
parishioners share fond memories of the Pastor and
what seemed a miracle one Christmas. The General
makes many comments on the quality of the wine
and the food. He reminisces about a female chef
who made the unique main course they are eating,
saying that her cooking blurred the line between the
physical and the spiritual. Then he rises and makes
the following speech:

"Mercy and truth have met together. Righteousness
and bliss shall kiss one another. Man, in his weakness
and short sightedness, believes he must make choices
in this life. He trembles at the risks he takes. We do
know fear. But no, our choice is of no importance.

There comes a time when our eyes are opened and we come to realize that mercy is infinite. We need only await it with confidence and receive it with gratitude. Mercy imposes no conditions. And lo! Everything we have chosen has been granted to us. And everything we rejected has also been granted. Yes, we even get back what we rejected. For mercy and truth have met together, and righteousness and bliss shall kiss one another."

(Note: The above is copied from the subtitles. The wording of the dubbed English version is quite different, though the meaning is the same—grace is in everything.)

The Film

Chosen as the Best Foreign Film at the 1987 Academy Awards, director/writer Gabriel Axel's *Babette's Feast* is a beautiful adaptation of Isak Dinesen's story. Over the past three decades, countless sermons have used *Babette's Feast* as an illustration of the transformative power of grace— you may find enthusiastic interest among clergy and lay leaders if you include this particular film in a discussion series.

It is rare to find a film version better than the original text. (*Cool Hand Luke* is another rare example.) In *Babette's Feast*, the story comes alive in a new way as the camera shows in glorious color the sumptuous feast that the writer barely describes in the original story. Viewers will find their mouths watering as the various dishes are carefully prepared and served to the guests.

The film centers on two daughters of the founder of a Lutheran sect, Filippa and Martine, who have passed up pleas from suitors to marry and raise a

family. Year after year, neither of the sisters could think of leaving their father and his charitable ministry among the villagers. After his death, they stay in the village, located on the harsh coast of Jutland, to carry on his charity work among their neighbors. They have taken in a servant named Babette, a refugee who fled a bloody conflict that swept across Paris in the 1870s.

Babette gradually takes over the cooking chores so that the sisters can spend more time visiting the sick and shut-in. The latter are doubly happy for this arrangement because the French woman's food is much more savory than that of the sisters. For many years, Babette serves the sisters and the villagers when they meet at the parish house for prayer meetings. With their minister long dead, fissures develop in the little congregation with various members holding recriminations against one another. But whenever Babette enters the room with a dish, they fall silent as if they fear her disapproval. The sisters are amazed at how much extra money there seems to be. They are unaware that since Babette took over the marketing, she had been more shrewd in her bargaining with the village merchants.

One day, several decades after her arrival, Babette wins a large sum of money in a French lottery. Everyone expects her to return to France now that she can be self-supporting. Instead, she offers to cook, at her own expense, a French meal for the sisters' congregation as they gather to celebrate the 100th birthday anniversary of their founder. The sisters are surprised by Babette's offer and only reluctantly assent to her plans. Adherents of a strict asceticism, they call a meeting of their parishioners. Everyone's respect for Babette leads them to cautiously accept

her offer. Their unease grows when Babette returns from a shopping spree in France bringing with her cages of baby quail, a huge live turtle, vast amounts of produce, and many cases of wine. The people agree to attend the meal, but not to take notice of the food.

Come the day of the feast, guests discover a dining room resplendent in fine china, a glittering array of silverware and lovely crystal water and wine glasses. The various courses that a local boy named Erik brings in from the kitchen (Babette never ventures from it) prove equally amazing: turtle soup, baba au rhum, Veuve Cliquot champagne and above all, quail stuffed with truffles and foie gras.

The parishioners merely nibble at the food, making no comment. However, as the meal progresses, the lovingly prepared food works its magic on them, and they consume it. A dear lady, mistaking the wine for lemonade (or is that her cover story?), asks for another glass.

Thus, the finely cooked dishes speak their own language and appeal not only to the physical senses, but to the spirit as well. This is made apparent when the guest of honor, the General (who had once courted one of the sisters), comments on each course of the meal. At the height of the meal, he rises to make a speech about righteousness and mercy, based on the old Pastor's favorite Psalm.

Some of the parishioners who had been alienated from each other seek to make amends. The General, who had come to strut his success before the woman who had rejected him, is humbled and brought to a new awareness of the faith he professed. After the meal and a sharing of another glass of wine, the

General parts with these words to Martine: " I have been with you every day of my life. Tell me you know that."

"Yes, I know it," she replies.

"You must also know that I shall be with you every day that is granted to me from now on. Every evening I shall sit down to dine with you. Not with my body, which is of no importance, but with my soul. Because this evening I have learned, my dear, that in this beautiful world of ours, all things are possible."

After the General and his aunt have left, the parishioners outside perform a lovely ritual that shows their reluctance to see the evening end. In the kitchen, Filippa and Martine congratulate Babette on her magnificent meal. They are surprised that she had been a French chef and are stunned to learn that she has spent all of her money on the feast. They call her poor, but her response shows no regret—part of that response being, "Throughout the world sounds one long cry from the heart of the artist: Give me the chance to do my very best."

For Reflection/Discussion

1. This is a superb resource for talking about the meaning of the Eucharist, especially the teaching of the Lord's Supper as a means of grace. Also suggested by this film: the metaphor in Jesus' teaching of the Kingdom of God as a Feast, as well as Christ's removing the boundary lines between "the spiritual" and "the material." In the three decades since the film's release, all of these themes have been explored in countless sermons. If you care to explore what others have said about these themes, search online for sermons about Babette's Feast and you will find

dozens (you'll also find related columns and parish newsletters mentioning the film). I was delighted than an article on the film that I wrote for the magazine *Christianity and the Arts* was quoted by novelist Andrew Greeley in his book he co-wrote with Albert J. Bergesen, *God in the Movies*.

2. This is also a great opportunity to discuss your spiritual sense of "vocation," or calling. It is a good closing theme if you have been discussing these films in a series. What is God calling you to do? What unique talents do you have? Are there forces in the community that keep people from following their vocation? Are there ways we can help people discern their vocation?

3. There are many ways to talk about this film! Choose some of the main characters (perhaps print out their photos and mount them on a newsprint pad). Ask participants to describe the characters and what values and passions have shaped their lives. What formed each one? And how is each transformed through the feast?

4. What do you think of the sisters' great sacrifice? Many Christians have chosen to lead lives entirely dedicated to serving others. What do you think of their model for doing this? Can you point to other models of Christians consciously denying themselves marriage or other pleasures in life as a part of their vocation?

5. Read John 2:1-11, the "Marriage at Cana." What connections do you see between that story from the start of Jesus' public ministry and the feast in the film?

6. Read the General's speech or view that scene again. What do you think of his message? Have you heard

some of these words before? What has the General learned about grace (or "mercy" as it may appear in your subtitles)? How does this differ from the villagers' understanding? Note that the Psalm he quotes at the end is Psalm 85.

7. What role does Babette play in the creation of this feast? Consider asking participants to list various roles Babette plays in this story: servant, artist, manager, teacher and more. Your list is likely to add many more. Talk about her roles in relation to her household and her community. Who plays such roles in your community?

8. There are many passages in the New Testament suggesting that the Kingdom of God is a feast or wedding banquet. The group might discuss the following passages: Luke 13:29, 14:15-24, 15:11-32, 22:28-30, 24:13-35 and Mark 14:22-25.

9. Compare this feast with dinners in your own family. Ask your group: In this film, does anyone remind you of someone you know at a family dinner? You might get an earful of responses! What role did food play in your family's holiday gatherings?

10. The most delicious idea is to focus on the food! Ask your group: What food summons the deepest memories and feelings for you? Is there a food you enjoy so much that you would describe it as a moment of grace? If this is the final film in a discussion series, consider planning ahead and asking participants to prepare food with a strong emotional attachment and enjoy a potluck or perhaps a dessert buffet.

CHAPTER 13

Who Do You Say That I Am!

So Many Jesuses!

SINCE THE FIRST 5-minute *Life of Jesus* appeared in 1897, countless movies from around the world have featured Jesus or Christ figures either as central characters or a key part of the story. The 12 complete study guides in this book represent a tiny portion of those films. Portrayals of Jesus range from the extreme word-for-word approach of *The Gospel of John* to the highly fictionalized, doubt-filled Jesus of *The Last Temptation of Christ*.

None of the Jesus films—not the 6-hour miniseries *Jesus of Nazareth* nor the earnest *The Gospel of St. Matthew*—offers a full picture of Jesus. He is too complex a figure. The four Gospels in the Christian New Testaments emphasize different themes in Jesus' life, death and resurrection. So, too, have Christian writers over the past 2,000 years. It's no surprise that film portrayals of these stories vary widely.

For the most part, filmmakers are talented artists who choose to include stories related to Jesus or the Christ figure to express their particular beliefs and questions to viewers. Like

pieces of precious stones in a mosaic, each film contributes to filling in the portrait of the Man From Nazareth.

The filmmakers are giving their own answers to the timeless question posed by Jesus: *"Who do you say that I am?"*

In this final portion of the book, I am summarizing other films you are likely to encounter if you organize a discussion group and dig further into this theme.

Early Jesus Films

Through almost 18 centuries artists have depicted Christ in every medium, but he was always frozen in a moment of time—except, of course for the Passion plays that grew up during the Middle Ages. Then, at the end of the 19th century, a new art form became available—the motion picture. Jesus has been a part of the film scene ever since the dawn of movies. One of the first narrative films was a 5-minute-long *The Passion of Christ*, shot in 1897 in France. Soon, the nonviolent rabbi from Nazareth who largely shunned the limelight had become Jesus Christ, Movie Star.

A number of Jesus films were produced during the following years. One in New York falsely claimed to be "The Original Oberammergau Passion Play," but was actually filmed on a hotel rooftop in Manhattan. In 1903, the French company Pathe released their version of a Passion play, *The Life and Passion of Christ*. It was re-issued in 1914 with new scenes under the title *The Life of Our Savior*. In 1912, American Sidney Olcott directed what was then a major length film, (1 hour, 12 minutes) *The Manger and the Cross*, shot in the Middle East.

In 1916, the great film pioneer D.W. Griffith focused a section of his 4-part film, *Intolerance*, on the trial and crucifixion of Christ. This was the first film to raise controversy over anti-Jewish imagery in a film about Jesus. Ignoring the Gospel accounts that make it clear Jesus was crucified by Romans, Griffith showed Jewish figures carrying out the execution. When the B'nai B'rith objected to this, Griffith admitted his

error and burned the negative of this scene. He reshot the sequence with Roman soldiers crucifying Jesus. Thus, the controversy surrounding Mel Gibson's film *The Passion of the Christ* was not the first brouhaha stirred up by a Jesus film concerning who was responsible for Jesus' execution.

King of Kings (1927)

The most lavish of the Jesus films before the advent of sound was Cecil B. DeMille's *King of Kings*. At 155 minutes, this epic was as much fiction as fact. DeMille was famous for trying to bring plenty of violence, sex and spectacle to his films. He rarely worried about historical accuracy and, in this case, departed wildly from biblical fact. How wild did he get? In one scene, Mary Magdalene is shown driving a chariot pulled by zebras! The courtesan is off to find out why her lover, Judas Iscariot, has not returned from his visit to some Jewish prophet named Jesus. Find that in your New Testament! This mixture of sex, action and sacred themes sold tickets—and would become the model for many subsequent Hollywood "sand, sandals and swords" versions of Bible stories.

This movie now is available in DVD editions and boxed collections of DeMille's films. In the film, DeMille depicts Jesus as a stately man, especially kind to children. The scene in which he heals a small, blind boy is as sentimental as any found in the movies of DeMille's great contemporary Charlie Chaplin—and equally moving for viewers. I find this movie difficult to watch, but it remains popular with viewers. One reason for this is that the film set many milestones in Hollywood history. It was the first major film to debut at the famous Grauman's Chinese Theater in Los Angeles. One of the big gates in this movie was later used in the original *King Kong*. If you watch a properly restored version of this film, you will be surprised by two early Technicolor scenes—which startled audiences in 1927—one early in the movie and another one during the resurrection.

From the 1930s to the 1950s

During the '30s, movies such as *The Sign of the Cross* and *The Last Days of Pompeii* focused on the persecution of Christians. However, the major Hollywood studios produced no feature-length films about Jesus' life. In England, the British Board of Film Censors went so far as prohibiting filming the face of Jesus.

A 1935 French film *Golgotha*, also known as *Behold the Man*, played all over Europe and in the United States. However, the British public was not allowed to see it—even though one of the great stars of France, Jean Gabin, played Pontius Pilate. While that 1935 film is difficult to find today, it remains notable for fans of Gabin. He was most famous for portraying tough guys and criminals—sort of a French Humphrey Bogart. Religious roles framed his long career: He appeared as Pilate in his 20s; in his 70s, Gabin donned a priest's collar in *Holy Year*, a movie about escaped criminals trying to get their hands on a stash of gold. It was the last film he made.

During the war years of the '40s, there was no commercial interest in making a Jesus film. With the '50s came an upsurge in concern for religion, with such grand-scale films as *Quo Vadis?* (1951) and *The Robe* (1953). In these films, Jesus was an important influence on the characters, but he was shown either from a distance or just in part (for instance, we see Marcellus in *The Robe* gazing up at the crucified Jesus, but just the feet of Jesus are shown). Each film did well at the box office, delivering what their feared rival, television, could not—lavish costumes and sets and epic action projected in full color upon a screen so enormous that it made the home TV set seem like a postage stamp!

Day of Triumph (1954)

During the '50s, evangelical groups such as Billy Graham's organization began producing religious movies. The

Rev. James K. Friedrich was the head of Cathedral Films, which made movies in the '40s and '50s—most notably the feature-length *Day of Triumph*, which was widely shown in theaters. Although the actor playing Jesus, Robert Wilson, was not a star, two in the supporting cast were: Joanne Dru as Mary Magdalene and Lee J. Cobb as Zadok, a Zealot dedicated to overthrowing the Romans.

Along with a number of miracles and teaching scenes from the Gospels, the filmmakers included much fictional material. For example, in *Day of Triumph*, Judas becomes a Zealot with a grand plot to turn Jesus into an earthly ruler. This Judas is convinced that Jesus' ride into Jerusalem with crowds hailing him as the Messiah would lead to Jesus taking power over the Romans—obviously a miscalculation.

Robert Wilson's Jesus in this film is a bit stiff, and the producers used music like an audio halo each time Jesus spoke. However, for its time, the film was good enough to be shown in theaters. Later, many churches screened it, mainly to youth groups. You may be able to find the film on VHS tape or low-quality scenes on YouTube.

He Who Must Die (1957)

During the McCarthy era, when the black-listed American director Jules Dassin fled to France in order to continue working in film, he created this powerful Jesus Transfigured film. He adapted it from the novel by Nikos Kazantkakis (author of *The Last Temptation of Christ* and *Zorba the Greek*). Set in a Turkish occupied portion of Anatola in the early 1920s, it answers the question raised by one of the characters in the film, "What would happen were Jesus to come today?" Under the guidance of their autocratic priest, villagers are chosen for the cast of the annual Passion play to be presented on Good Friday. The priest announces to the assembled villagers that the stammering shepherd Manolios will be Christ; the village butcher will be Judas; the son of the Mayor will be Peter; the

widow-prostitute will be Mary Magdalene, and so on. Then, a group of refugees, led by another priest, arrives pleading for help. They are the survivors of a massacre after their village rebelled against their occupiers. The village priest refuses, afraid that the local governor would be upset. He is also concerned that the refugees would be an economic burden. He demands that they move on, even though they are starving. When the shepherd chosen to be Christ, along with several of his "disciples," opposes the heartless priest, a struggle for moral leadership ensues—leading to a form of betrayal and crucifixion. This Jesus Transfigured film is a powerful drama, accessible today on YouTube.

King of Kings (1961)

Nicholas Ray, best remembered for directing *Rebel Without a Cause*, presents a youthful, athletic Jesus, depicted by Jeffrey Hunter in *King of Kings*. This film has no ties with DeMille's 1927 epic other than its name. Ray's film is so bloated and pretentious that much of its religious message is overshadowed by the spectacle, especially the fictional battle scenes. There is little sense of the Jewishness of Jesus—Hunter's non-Semitic face featuring eyes as blue as the Western sky. I will never forget the caption that TIME magazine placed with the photo of the crucifixion: "They shaved his armpits." Only a squeaky clean Jesus would do at MGM. This film begins in 63 BCE with the Roman general Pompey entering Jerusalem after a long and bloody siege. He rides his horse up the temple steps, and when the chief priests block his way, he orders them all to be speared to death. He enters the Holy of Holies expecting to find gold-covered idols, but finds only the Torah scroll.

The rest of the film is a pastiche of Gospel and fictional accounts with Herod Antipas and his queen and daughter-in-law in many scenes, as well as a Roman officer named Lucius. The latter begins to admire Jesus as he comes into contact with the Holy Family through the years. As if the Gospel stories

did not contain enough drama, there are two battle scenes inserted: one when Pontius Pilate begins his rule, and another on Palm Sunday—both of them involving a revolt of the Zealots led by Barabbas.

Jesus' greatest miracle, the raising of Lazarus, is left out. The miracles that are depicted happen more by accident than by Jesus' intention to show them as signs of the kingdom of God. He seems to have little understanding of his mission—in one scene he has returned home for a respite and is repairing a chair when the disciples come in and say it is time to go to Jerusalem. Jesus lays the chair down and says that he will finish it when he returns, but Mary says that he will never finish it. Throughout the film she seems to know more about her son's fate than he does.

The Last Supper depiction is unique in that the group is seated around an X-shaped table. Ray and his team also went to great lengths to emphasize that the Romans condemned and executed Jesus. There is no danger of anti-Jewish stereotypes in this Hollywood epic.

The Greatest Story Ever Told (1965)

Soon, United Artists also jumped on the biblical bandwagon. George Stevens' 1965 spectacular, *The Greatest Story Ever Told*, was overly reverential. If Jeffrey Hunter seemed to be an odd ethnic choice to play Jesus, Stevens turned to Scandinavia and cast Swedish actor Max Von Sydow as Jesus. While von Sydow was brilliant in the somber films of Ingmar Bergman, he was far too dour and slow-moving to make an effective Jesus! The supporting cast seems to have included every major star connected with the studio: Charleston Heston, Sidney Poitier, Pat Boone, Carroll Baker, Dorothy McGuire, Telly Savalas and even John Wayne (horribly miscast as a centurion at the cross).

This movie is most notable as a Hollywood who's who from that era. Other stars in cameos include Richard Conti, Jose

Ferrer, Van Heflin, Martin Landau, David McCallum, Roddy McDowell, Sal Mineo, Donald Pleasance, Claude Raines and Shelly Winters. The overall effect is a dilution of the Gospel drama. Stevens' decision to shoot the film in the American West only served as a distraction. Thus, Jesus is often over-shadowed by spectacular views of canyons and buttes in Arizona and Utah that in no way make us think of the real Galilee or Jerusalem.

The Swedish actor's Christ is so dignified and slow of speech—and the editing so languid—that you wonder how Jesus ever got anything done. The director's use of so many long shots makes Jesus seem very distant from our human sit-uation. In one scene, Jesus and the disciples sit under a bridge where he is teaching them. Overhead, a series of travelers pass by, some of them stopping to listen. Mostly shown in long shots, the travelers above the little band divert our attention from what Jesus is saying. In the end, the movie seems more like a stodgy pageant than a film.

One notable exception is the effective Temptation scene in which the script eschews the spectacular approach of other Jesus films for a more personalized one: Satan is portrayed as an old hermit in a cave, tempting the newly baptized Jesus to follow paths that would draw attention to himself rather than fulfilling his divine mission.

Godspell (1973)

John-Michael Tebelak and Steven Schwartz's *Godspell* was the second of three musical versions of Jesus' story that came out in 1973. I would categorize it as a Jesus Transfigured film in that it is set in 20th-century Manhattan.

This time, Christ is a clown who charms the hearts of his followers by singing and dancing his teachings. Victor Garber plays a hippie Jesus in a Superman T-shirt as the painted-face leader of a troupe of clowns. He and John the Baptist bring joy, merriment and love to an assorted group of Manhattan

dwellers trapped in the urban routine of noise and rush. The script focuses on the teachings, rather than the miracles of Christ, and presents them in highly imaginative ways through pantomime, vaudeville jokes and pratfalls—and, of course, in song and dance.

The movie is more than half over before we see the opposition to Jesus, embodied in a huge puppet-machine that snarls at Jesus, challenging his authority to teach and make changes. When Jesus tears away the cover of the machine, we see that the disciples are within it, manipulating its arms—perhaps implying that they too harbor opposition to Christ.

The mood of the film immediately turns from that of merriment and spontaneous joy to one of somber introspection as Jesus gathers his friends for his Last Supper to prepare them for his impending crucifixion. Unlike *Superstar*, there is a type of resurrection after his execution. Jesus' disciples carry his body aloft along a city sidewalk as they chant "long live God" in somber fashion. This changes to the opening song "Prepare Ye the Way of the Lord" as they round a corner and are thrust back into the turmoil of the city, showing that Christ is alive in them amidst the hustle and bustle of life.

Most of the music is sprightly and memorable, with "Day by Day" appearing in the top 20 on the charts. I have often used the video, and I am glad that churches and community theater groups are still staging it. Overly sober Christians often need to be reminded of the humor in the Gospels and of the concept that the story of Christ, in traditional stage terms, is a comedy, not a tragedy.

Gospel Road: A Story of Jesus (1973)

The third 1973 musical Jesus movie was produced by Johnny and June Carter Cash. As Johnny approached age 40, he re-emerged as a cleaned-up performer publicly proclaiming his Christian faith. Part of that effort was the creation of the album and a 93-minute movie called *Gospel Road*. The

exact titles have varied slightly in editions of the album and the movie over the years.

Cash wrote and performed songs and narrated the low-budget movie, which he and his wife June Carter Cash personally bankrolled. At the time, the New York Times reported that the movie was being cautiously distributed by Fox, mainly aimed at Cash fans. Overall, the Times gave the effort a positive spin: "Johnny Cash looks 10 years younger. He has lost the tension in his mouth, the burned-out look in his eyes that lasted after his self-destructive decade. He is 41 years old and he bounces like an athlete when he walks. … They say the difference is in his religious experience in recent years—'the coming back to Jesus' as he put it."

Cash fans still are drawn to this unusual, personal project. However, I find the acting in the movie very wooden. Some scenes appear more like a bad church pageant than a feature film. I have shown scenes from this movie to discussion groups, drawing laughter at the more awkward moments. Still, there are a few moving scenes and, of course, it's always good to listen to Johnny Cash's music.

Jesus of Nazareth (1977)

Controversy arose in 1977 over NBC's showing of *Jesus of Nazareth* because filmmaker Franco Zefirelli made an unguarded comment during an interview that he wanted to emphasize the humanity of Jesus in his film. Even though he had not seen the film, evangelical activist Bob Jones mounted a campaign to force the network to cancel the miniseries. The major sponsor was so intimidated that it withdrew—but to NBC's credit, the miniseries aired.

As a result, millions of viewers followed the film from night to night, probably more than had watched all of the other Jesus films combined. What they saw was a well-produced drama that drew on all four Gospels.

A director of operas and films (his 1968 film *Romeo and Juliet* was a big hit), Zefirelli shows his familiarity with the great masters who painted Christ. The architectural framing of the characters, the careful symmetry in the way he stages his figures—all show the influence of Renaissance artists. He also was careful to make the Jewish origins of Jesus unmistakable. Even though actor Robert Powell and others are plainly British, their costumes, the scenes set in the synagogues, the dancing at the wedding in Cana and a Passover meal that becomes the Last Supper are all depicted in a Jewish context.

Actor Robert Powell's Jesus is a great storyteller. He tends to look up or beyond the persons he is addressing and makes himself seem distant from his companions, as if his mind were set on his Father's kingdom. Contrary to fears of conservatives, the depiction of Jesus showed both his divine and human natures.

The Jesus Film (1979)

The film *Jesus*, sometimes called *The Jesus Film*, was released in 1979 through Warner Brothers. It stands in stark contrast to such films as *King of Kings* and *Jesus Christ Superstar* in that it stays very close to its Gospel source (mainly St. Luke).

Jesus began as part of a grand proposal to make movies about the entire Bible. This film was backed by Campus Crusade for Christ and its major philanthropist: the oil billionaire Nelson Bunker Hunt.

Top Hollywood professionals worked on this project and others in the series. Producer John Heyman also made a 1979 film known as *The New Media Bible: Book of Genesis*. The entire project is remarkable for its attempt to stay as close as possible to the biblical texts.

Unfortunately, *Jesus* did not earn enough at the box office to recap its $6 million budget and would have been forgotten if it were not for its video version. Campus Crusade founder, Bill

Bright, promoted the video as an effective aid for evangelism, and thousands of pastors have shown it to their congregations. Campus Crusade eventually made adaptations of the movie in 300 different languages. The film's supporters claim that several billion men, women and children have now seen the movie, making it the world's most-watched movie—a claim repeated in reporting by the BBC and The New York Times.

In this film, Jesus is a likable teacher. However, compared to Pasolini's revolutionary Jesus, he is a mild person who seems to pose little threat to the authorities until he cleanses the temple.

What disappoints me is that shorter versions of this film have been widely distributed, leaving out such parables as the Prodigal Son and the Rich Man and Lazarus—which I regard as two crucial stories about grace and concern for the poor. In fact, if you want to view the movie, you will find at least a half-dozen versions available—not to mention an updated version due out late in 2015 on Blu-ray. In some versions, additional footage has been added. In other versions, scenes are missing or the entire film is reduced to excerpts.

The Last Temptation of Christ (1988)

Director Martin Scorcese was a great admirer of Pier Paolo Pasolini's *The Gospel According to St. Matthew* along with another film made about that time by Roberto Rossellini, *The Messiah*. Even as a young boy raised in the Catholic Church, Scorcese wanted to write a play about the life of Jesus. Years later, friends introduced him to Nikos Kazantkakis's 1953 novel *The Last Temptation of Christ*—which is not a novel about the life of Christ, but a Jesus Transfigured story.

Eventually, Scorcese secured financial backing and cameras rolled. Scorcese was well aware that the original novel was controversial and had been banned in some parts of the world. Opposition to this version grew to hurricane proportions. One Mississippi-based Methodist minister mounted a

million-dollar campaign, urging church members to boycott the film—and that was just one of several major efforts to stop the film's release.

Finally, in 1988, the film made its way to theaters whose managers were not intimidated by the prospect of bomb threats and throngs of angry protestors gathered in front of their box offices. Those who protested the most against this film failed to see that neither novel nor film were the story of the Jesus of the Gospels, but a work of speculative fiction designed to bring back to people's attention the humanity of Jesus.

Scorcese took the self-doubting Christ from the novel and made him into a neurotic—fighting so much against his God-ordained call to die on the cross that he accepts the job of building crosses for the hated Romans in the hope that God would reject him. In one scene, Jesus writhes in agony on the ground, declaring that God is like an eagle sinking his talons into his brain. He calls disciples to follow him, but relates only to Judas—not Peter or "the beloved disciple" of the Gospels.

There are many sequences in this film that stand in stark contrast to all of the other Jesus films listed in this book. This is the only film that I know of in which Jesus smiles just before he dies on the cross. By 1997, the prestigious Criterion Collection issued its first special edition of the film for home viewing, updating the film's format in 2000 and 2012. At that point, little public outcry still existed about the movie.

The Cotton Patch Gospel (1988)

While this technically isn't a movie but a filmed version of a 1985 one-man stage performance, it is so good that it should be in every collection of films dealing with Jesus. A Jesus Transfigured version of Christ's life, Clarence Jordan transfers the story to modern-day Georgia, where "Jesus" is a good ole country boy hailing from Valdosta—though born in Gainesville. Harry Chapin finished the lyrics and music for this stage

performance just before he died in a car accident, and his collaborator, actor Tom Key, finished the book with Russell Treyz. The play opened off-Broadway in the fall of 1981.

Tom Key plays Jesus, the disciples, the Pharisees—virtually anyone Jesus encountered. The four-man country band occasionally becomes the crowd, or comments on the action like a Greek chorus. The dialogue is Southern, as shown by Jesus replying to the Devil's temptation to turn stones into bread: "Man does not live by grits alone." There is a lot of humor in the story and a biting edge. A highlight of the play is the song "Turn It Around," based on Jesus' teaching of nonviolence in the Sermon on the Mount. This is a great song to use with youth and children in a session on peacemaking!

From birth to death and resurrection, the story is told in an unforgettable way. For spectacle, the "cast of five" might not stand up to the big productions with their "cast of thousands," but for inspiration and moral challenge, this little film is the equal to all. And what glorious music Harry Chapin provided!

Judas (2004)

As in all films dealing with Jesus, the Last Supper is shown in this made-for-TV drama. The Catholic Paulist Productions was a partner in the filming that aired on ABC in 2004. As one might guess from the title, this is not so much a Jesus film as it is a movie about the relationship between Master and Betrayer.

The scriptwriters provide a backstory for *Judas*, showing him as a man living in Jerusalem with his mother and opposing Roman occupation so much that he gets into trouble with the temple authorities. At first he looks down on Jesus and regards the disciples as a bunch of country bumpkins. When Jesus meets him, and accepts his invitation to his home for a meal, Jesus invites him to join the band of disciples, adding the ominous words to his call, "If I am not too late."

The Romans are very much in command in this film. Because Jesus is really not the central character, the events of

Easter are not shown and the film ends with a disciple engaged in an act of compassion that will remind viewers of the Pieta, Surprisingly, it is not the body of Jesus, nor is it Mary doing the cradling of the body. It is Barabbas holding the body of the dead Betrayer.

The Gospel of John (2014)

With little fanfare, the Lumos Project released this second version of the fourth Gospel late in 2014 (to be followed by films of the other three Gospels in 2015). The director of the newest Jesus film is the noted TV producer David Batty. The text of John is read as the actors act out the story in Aramaic. There are two English versions: the NIV (New International Version), read by David Harewood, and the KJV (King James Version), narrated by actor Brian Cox. Soon, the Spanish language (Reina-Valera 1960) version will be released. The cast looks more ethnic than in other Jesus films, with the portrayal of Christ by Shakespearan actor Selva Rasalingam. The production values are excellent and the director does a fairly good job of making Jesus' long Upper Room Discourse visually interesting. Though the text is strictly from John, the filmmakers could not resist the tradional urge to harmonize the four Gospels. In the first chapter, when the narrator reads *"and the Word became flesh,"* we are shown Luke's and Matthew's manger scene. The Magi join the shepherds in adoring the newborn Child. This new version will be more educational than entertainment because it loses the immediacy of our hearing Jesus and the other actors actually speaking the dialogue. Though this version is worth seeing, it will not replace *Visual Bible's* far more gripping version.

Killing Jesus (2015)

Based on TV personality Bill O'Reilly's best-selling book, this miniseries shown on the National Geographic Channel is

intriguing because Lebanese actor Haaz Sleiman stars as Jesus. No one can object that he is not ethnic enough (no blue-eyed Jesus as in the 1961 *King of Kings*). However, there was objection to the actor's religion, Islam (as if a Muslim actor were incapable of playing a Christian). Although the title points to the crucifixion, the film begins with the events around Jesus' birth—King Herod's fear of his dynasty being supplanted, the visit of the Magi, the Nativity and the hasty flight of the Holy Family to Egypt. The adult Jesus is portrayed as uncertain about the nature of his calling. This Jesus is not the figure supremely confident of his authority as depicted in the four Gospels, struggling at first in the wilderness over the form of his messiahship. Rather, he emerges as the Christ of Isaiah 53, bent on his mission to save his people from themselves. Little of his healing and teachings are shown. The film concentrates more on the political machinations of High Priest Caiaphas, Herod Antipas and his scheming wife and Governor Pontius Pilate. The crucifixion is powerfully depicted, but the resurrection is left up to the viewer, similar to *Jesus Christ Superstar*. The film failed to garner much support and viewers reacted negatively.

A.D.: The Bible Continues (2015)

Just a week after *Killing Jesus*, NBC aired the first film of their new miniseries that was produced by the husband and wife team of Roma Downey and Mark Burnett. Though considered a sequel to *The Bible*, this features a different actor as Jesus, the Argentinean Juan Pablo Di Pace. Unfortunately, a large portion of the casting was ultimately distracting.

Additionally, the crucifixion scene proves regrettable because only one of the so-called seven last words of Jesus is used. Otherwise, the events of the trial and execution are well staged. Not so commendable is the "Hollywoodizing" of the resurrection. Instead of keeping the event off-stage, as the Gospel writers do, the filmmakers bring in one of the

ninja-like angels and spectacular effects that marred *The Bible*—the angelic sword wielder standing above the tomb in plain sight of the Roman soldiers guarding the tomb. Much of this and most of the second part of the miniseries focuses on the anxious Caiaphas' attempt to track down the "stolen" body of Jesus and stay on the good side of the angry Pilate. Not recommended for serious viewing and discussing. Viewers would do far better watching the 1985 TV miniseries *A.D.*, based on the Book of Acts, available in a 6-hour version from Vision Video.

Want to Know More?

Visit www.ReadTheSpirit.com/Visual-Parables/ to discover
Ed McNulty's leading resource for faith-and-film reviews and
study guides, as well as his other books.

About the Author

DR. EDWARD MCNULTY is a Presbyterian minister who has been relating films to faith for over 40 years. A graduate of McCormick Theological Seminary, he has served churches in West Virginia, Pennsylvania, Ohio and New York. His writing began in 1970, growing out of work with children and youth. The first two of his 13 books were printed in 1976. He has written over 2,000 articles and film reviews in Catholic- and Protestant-sponsored magazines and newspapers, and now for ReadtheSpirit.com and *Lectionary Homiletics*. All three of his books from Westminster/John Knox Press dealt with film and faith.

In 1990, McNulty founded the journal *Visual Parables* to help educators and pastors find and use good films for their ministries. During the '90s, he earned his Doctor of Ministry degree from United Theological Seminary in the field of art, film and theology while also heading up a popular film series in a Dayton movie theater. He presented popular film seminars related to the theme of the Presbyterian Peacemaking Conferences.

Dr. McNulty has taught at elder hostels, seminaries, colleges, churches and camps from Massachusetts to California and Canada. He has produced programs and "spots" for television and radio that have been used around the country. He collaborated with Hollywood film director Michael Rhodes to develop Film Clips. He is married to Sandra H. McNulty, a talented banner maker, and is the father of five grown children. He now lives in Kentucky.

Our Story

Since 2007, ReadTheSpirit Books has been publishing authors with a purpose: to improve our world, one story at a time. Media means connection. We often say: Good media builds good community.

We believe that our readers—men and women just like you, all around the world—are a part of this larger effort to connect lives through the stories we tell. You can help by simply telling friends about this book and encouraging them to start reading. Most of our books are designed for individual reading— and also for small-group discussion. So, please consider inviting friends to discuss this book with you.

We always appreciate hearing from readers like you. Want to thank the author? Ask a question? Suggest an idea? Find out about author appearances? Just email us at ReadTheSpirit@gmail.com

The book you are holding is part of a larger collection of books by writers that encourage peacemaking, celebrate diversity, strengthen caregivers, rebuild impoverished communities, train the next generation of leaders and, most importantly, inspire each of us to enjoy a better day.

Please, take a moment to look at some of the other ReadTheSpirit books you may enjoy reading. Your next inspiration is just a book away.

Related Books

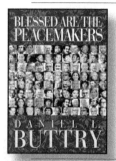

Blessed Are the Peacemakers
Daniel L. Buttry, 2011
In the pages of this book, you will meet more than 100 heroes, but most of them are not the kind of heroes our culture celebrates for muscle, beauty and wealth. These are peacemakers. Watch out! Reading about their lives may inspire you to step up into their courageous circle.
www.InterfaithPeacemakers.com

ISBN: 978-1-934879-23-8

Interfaith Heroes 1 & 2
Daniel L. Buttry, 2008
These two volumes profile more than 70 interfaith heroes, spiritual leaders and peacemakers throughout time and across the globe. These courageous men and women crossed traditional boundaries of religious groups to build stronger communities.
www.InterfaithPeacemakers.com

ISBN: 978-1-934879-00-9

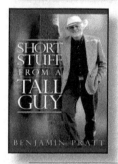

Short Stuff From A Tall Guy
Benjamin Pratt, 2015
For the first time in book form, author and counselor Benjamin Pratt collects dozens of his true-life stories that invites readers on a spiritual journey marked by compassion, humor and honesty about dilemmas, doubts and challenges that men and women face everyday.
www.ShortStuffFromATallGuy.com

ISBN: 978-1-939880-90-1

Ian Fleming's Seven Deadlier Sins & 007's Moral Compass
Benjamin Pratt, 2008
The world's most famous secret agent is known for elegant style and nail-biting suspense. Now, inspirational writer Benjamin Pratt unlocks deeper values that fuel James Bond. This book is a great choice for church groups and for anyone in high-stress public service.
www.ReadTheSpirit.com

ISBN: 978-1-934879-11-5

Print and ebooks available on Amazon.com and other retailers.

Related Books

Life Doesn't Get Any Better Than This
Robert Alper, 2015

Life Doesn't Get Any Better Than by This is a collection of true stories, from tales of fatherhood to a touching recount of the way small gestures lodge themselves in your heart, from Rabbi Bob Alper.

www.BobAlper.com

ISBN: 978-1-939880-87-1

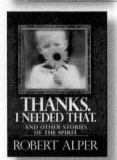

Thanks. I Needed That.
Robert Alper, 2013

The Tonight Show, the forests of Vermont, and a tiny Polish village are among the settings for these 32 true stories by Rabbi Bob Alper. Bob's unique experiences, from leading large congregations to performing stand-up at Toronto's "Muslimfest," make for a wealth of engaging stories.

www.BobAlper.com

ISBN: 978-1-934879-86-3

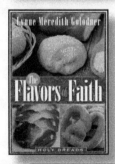

The Flavors of Faith: Holy Breads
Lynne Meredith Golodner, 2013

Enjoy eating? Fascinated with faith? Like to share with friends? You'll love this book about timeless spiritual connections between food and faith. Enjoy stories that circle the globe, then step into your kitchen to make breads from sacred traditions. Includes recipes.

www.TheFlavorsOfFaith.com

ISBN: 978-1-934879-51-1

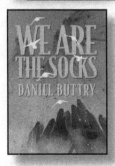

We Are The Socks
Daniel L. Buttry, 2015

Every day, we hear news from around the world about war and violence. But who could hope to make a difference in these tragic conflicts? The idea of peacemaking seems impossible—unless you're Daniel Buttry, ordained minister and seasoned peacemaker,

www.InterfaithPeacemakers.com

ISBN: 978-1-942011-03-3

Print and ebooks available on Amazon.com and other retailers.

CPSIA information can be obtained
at www.ICGtesting.com
Printed in the USA
BVHW070431290122
627220BV00002B/200